HOW TO BREAK INTO

PRODUCT DESIGN

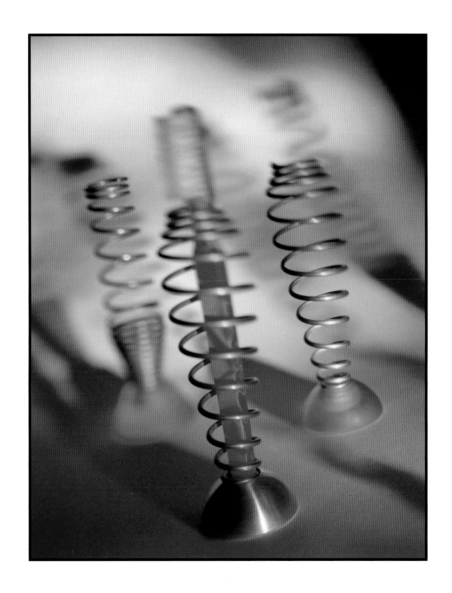

PAMELA WILLIAMS

NORTH LIGHT BOOKS

CINCINNATI, OHIO

Other fine North Light Books are available from your local bookstore, art supply store or direct from the publisher.

02 01 00 99 98 5 4 3 2 1

Library of Congress Cataloging-in-Publication Data

Williams, Pamela (L.)
 How to break into product design/Pam Williams.
 p. cm.
 Includes bibliographical references and index.
 ISBN 0-89134-829-8 (alk. paper)
 1. Design, Industrial. 2. Graphic arts. I. Title.
TS171.W54 1998
745.2–dc21 98-15667
 CIP

Edited by Kate York and Lynn Haller
Production edited by Patrick Souhan and Marilyn Daiker
Book design by Lou DiBacco, DiBacco Design, Avon, Connecticut
Interior production by Ruth Preston
Photography by Jim Coon and Christine Rudolph, Jim Coon Studios,
 Hartford, Connecticut
Other Photography: Page 12/CD holder: Holly Stewart • Pages 52 and
 59/Vanderbyl furniture: David Phelps
Page 120/Magnetic Poetry Wall, © Magnetic Poetry
Models: Pages 12, 37: Roberto Alfaro • Page 32: Jennifer Reising • Page 92:
 Hannah Howard
Stylist: Valerie Petrarca; Modeling Agency: Johnston Agency
Illustrations in chapter eleven by Ward Schumaker
The Zolo Inc. illustrations on pages 128–129 are reprinted with permission.

Thank you to each of the designers who were willing to share their time and expertise in the research and writing of this book. It's their stories that give this book life.

Many thanks to Jim Coon, Chris Rudolph, Lou DiBacco, Christopher Forbes, Lynn Haller, Kate York, Angela Wilcox, Bev Williams, Jack Williams, Colleen Duffy and last, but definitely not least, Brian Kelly.

TABLE OF CONTENTS

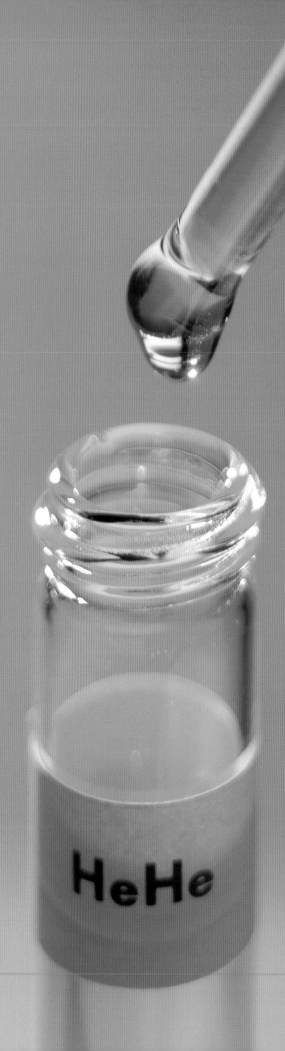

A few years ago, in the North Beach section of San Francisco, I wandered into Fillamento, an eclectic home furnishings store. Upstairs I found a square metal box. Inside, five test tube-type vials were lined up as uniformly as the periodic table of elements. My nose told me they were fragrances; the labels told me their creator had a whimsical sense of humor: OoAh, X_2C, HeHe, Y and IM_4U.

Loosely based on the principles of aromatherapy, Applied Chemistry™ enables its owner to become an alchemist. A book of concoctions inside the set (which, the text warns, you must not take too seriously) purports to help you mend a broken heart, attract a man, attract a woman, make more money, enhance your memory and inspire imagination.

Applied Chemistry was thoughtfully conceived, simply and elegantly designed, and flawlessly manufactured. Whoever had created this was smart. They had the good sense to hire a designer. I flipped the box over. The product had been created by Higashi Glaser, a design firm based in Virginia. Bravo, I thought, and bought one on the spot.

Getting into product design has literally become a marketing strategy for dozens of graphic designers in the United States and around the world. In the last few years, hundreds of designers have successfully entered the field. In fact, many designers say they want to shift their revenue base to emphasize product design vs. graphic design. Why? The benefits of product design add up to a sustainable competitive advantage. Your involvement in product design will give you the knowledge, experience and resources to:

- Be a better, wiser counselor to your existing clients.
- Create a supplemental revenue stream.
- Put yourself in the driver's seat.
- Create something of lasting value.
- Increase and enhance your visibility in the marketplace.

This book was created to provide you with practical insights. It will systematically walk you through the product design and marketing process while providing you with helpful guidance along the way. Based on the real-life experiences of thirty graphic designers and a handful of other experts who have successfully designed and marketed more than eighteen hundred products in twenty-eight different product categories, *How to Break Into Product Design* is the first comprehensive book on this subject.

This book will be helpful if you're interested in designing and marketing products which are generally niche market vs. mass market, low tech vs. high tech (design of watch face vs. design of casing and engineering of timing mechanism) and are driven by functionality, innovation and aesthetics.

On the pages that follow, you'll find sensible information which will help you take your idea from a simple sketch to a stock-keeping unit (sku). You'll be exposed to a whole new world: a world where

WHY PRODUCT DESIGN?

You've got this killer idea.

You've been thinking about it for days, weeks, maybe months. It's new. It's original. It will set the world on fire. You can't stop thinking about it; everyone you know would buy it.

You want control.

You're frustrated by the project-oriented nature of the graphic design industry. Tired of the "feast or famine" syndrome. Tired of finding yourself at the mercy of clients who may…or may not call. You don't want to wait for the order; you'd prefer to write the order.

You want to be the client.

Nothing against clients, but, just this once, you want to do something that pleases you 100%—something for which you can take complete creative control and responsibility.

You're looking for something new.

You've done the two-dimensional thing. Working in three dimensions appeals to you because it will enable you to think through the process of design in a whole new way.

You want more visibility.

Each product you design is a tangible representation of your work in the marketplace. Many designers find their product designs help increase their visibility to prospective clients.

You want to make more money.

Maybe you want to supplement your present income. Or maybe you're looking for an entirely new revenue stream.

You want to create something of lasting value.

You'd like the opportunity to design something that stays around longer than a report to shareholders or an invitation to an annual meeting. Something that people really want. Something that will enhance their lives. Something that someone will keep. Something that might make a difference.

You're concerned about the future of design.

In some sectors of the industry, such as publication work, design has become a commodity. Desktop publishing equipment doesn't make nondesigners good designers, but it is a legitimate competitive threat.

You want to be a better graphic designer.

You'll learn that turnover is more than a breakfast food. Expanding your horizons into product design will make your client graphics more focused and relevant. Exposure to new ways of thinking will make you a better thinker and problem solver. Present and prospective clients will take you more seriously.

margins mean more than the perimeters on the pages of a brochure and markup has absolutely nothing to do with proofing bluelines to send to your printer. A special section at the end, called Access, is included to enhance your knowledge in specific subject areas. By reading this book, you'll be able to answer such questions as:

- How do you know if you have a good idea?

- How do you know if the idea you have is marketable?

- Should you invest a lot of money in creating a prototype?

- What's the best way to take your product to market?

- Is licensing right for you?

- How much money do you need to get started?

- Should you look for investors?

- What do you need to know about pricing?

- How do you determine the quantity of an initial production run?

- How many units can you expect to sell the first time out?

- Where should you start?

Those who have been there themselves will tell you what you should do and what you shouldn't do, what they've learned and what they'd do differently if they had to do it all over again.

Come with us as we leap into the world of product design.

If there's something that you've wanted to create for a long time, do it. Do it in your mind, construct it, become your own client. Just work it. Work it really hard because at the end of the process you may have something of great value. (Even if you never take your product to market) I can guarantee you that your thinking will be sharpened and you'll be fuller as a designer for having gone through the product design process.

—Michael Cronan
Cronan Artefact

A BIT OF FOOD OR A SMALL BONE FROM YOUR MOUTH: 1. USE

IF FOOD IS TOO HOT OR TASTES SPOILED, DON'T SWALLOW

HOW TO TAKE CARE OF SPILT FOOD:

IF YOU SPILL PART OF
YOUR MEAL ON TO THE TABL
PICK UP AS MUCH AS YOU CAN
YOUR FORK OR KNIFE. APOLOGI
YOUR HOSTESS, WHO SHOULD NO
ATTENTION TO THE ACCIDEN

CHAPTER 1

If you already have a great idea for a new product, skip to chapter two. If not, start your foray into product design by thinking about

getting these questions:

(**1**) What do you need that you can't find? What do you wish you had that you haven't seen before?

(**2**) What do you know a lot about? What are your areas of expertise? What do you know more about than anyone else you can think of?

(**3**) What interests do you have? *started*
What are you passionate about?

(**4**) What can you do or make better than anyone else you know?

(**5**) What trends support or negate the product ideas you have in mind?

No two persons will answer the questions the same way. What you'll wind up with will be totally unique and totally your own. This, of course, is a good first step toward creating a product that is without rival in the marketplace.

Whether you approach the assignment intuitively or systematically, informally or formally, your thoughtful responses will help you determine a direction that's right for you. It may take a while. Don't worry. When the time is right, you'll see a pattern emerge. Think of this as a puzzle that will come together, piece by piece.

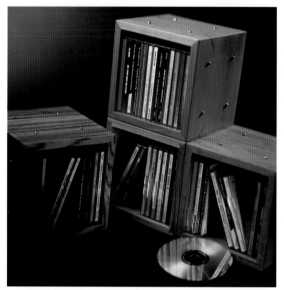

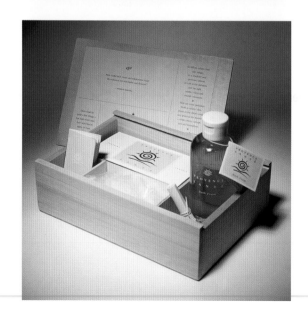

how they got started

At 6'4" and more than 200 lbs., it's not easy for Michael Cronan to find clothes that fit, much less garments that are comfortable. This need, coupled with the desire for apparel that could take one through the day seamlessly, was one of the driving reasons he and wife/business partner, Karin Hibma, started an apparel line called Walking Man. The line is casual, functional and comfortable. Core products such as the Urban Uniform and the Great White Shirt have earned Cronan Artefact a loyal following.

Mark Sackett is a collector. His Pacific Heights, California studio is full of antique toys, game boards, dolls and antique papers. He also loves music and buys new CDs all the time (he has more than 850). Problem was, he had nowhere to store them. The drawback he saw to most commercial storage systems was that they fill up too fast, they're inflexible and undesigned. Recalling his college days, the way he stored albums in orange crates, Sackett envisioned a CD stacking system that would be modular and designed to grow vertically or horizontally—one cube at a time—with the owner's collection.

Part owners of Baudelaire, an importer of soap and body care products, Adrienne and Jeff Pollard are both avid readers and environmentalists. Adrienne is also an accomplished letterpress printer, binder and bookmaker. Embarking on the design of a gift box to contain a sampling of products from Baudelaire's Provence Sante line, the Pollards created a limited edition Poetry Box. Each compartment of the reusable, Joseph Cornell-style shadow box includes a different product accompanied by images, poems and writings that reveal the origins of the fragrance and its relationship to the senses.

IDENTIFY WANTS AND NEEDS

One way to start brainstorming is to identify wants and needs in the marketplace. You might think about this on a macro level (national/international) as well as on a micro level (your own experience).

WATCH TRENDS

For starters, make lists of trends that might inspire or affect the product you have in mind. The best way to identify trends is by reading, observing and asking questions. Read everything you can get your hands on. Newspapers, magazines. Watch TV. Go on-line. What do people complain that they don't have? What will make their life better? What will enhance their experience?

MERGE TRENDS WITH WANTS AND NEEDS

Faith Popcorn, president of BrainReserve and author of a number of best-selling books on the future, correctly predicted the rise of "cocooning," a trend in America toward retreating into the home. She also identified a phenomenon she calls "cashing out," having observed that women and men are leaving the corporate rat race in droves, in search of a better quality of life. How will these trends affect consumer habits in the environments where they spend the majority of their time: at work, at home and at play? What new products will they be inclined to buy? Travel is predicted to be one of the fastest growing industries by the turn of the millennium. What kinds of new products might this trend inspire?

There are a number of places to look for trends. For example, American Demographics/Marketing Tools (magazine publishers) have a Web site which offers trend and demographic information as well as market research reports: www.demographics.com. For more resources on trends, see "Trending" in chapter twelve.

To be creative you need to feel comfortable being lost and in deep trouble. You must enjoy absurd, contradictory, outrageous possibilities. You need to be a lover of exploring uncharted territory, and, most of all, you need enough self-confidence to fail.

—McRay Magleby

Thinking about the products you might design and take to market? Graphic designers around the country have successfully designed products in every one of these categories, on their own, through a licensing agreement or as work-for-hire. You might use this as a reference to brainstorm your own product ideas.

Product Categories	
Paper Goods Stationery Greeting Cards Gift wraps Posters Limited edition prints/art **Personal Care** Fragrances Cosmetics Bath products Body care products **Furnishings for Home or Office** Furniture Rugs Pillows Lighting Decor **Publishing** Cookbooks **Tabletop/Tableware** Dishes Glassware Table settings Mugs Teapots/Coffeepots Coasters **Tools for Designers** Artwork Typography	**Gifts/Giftware*** Frames Plus many other items **Kitchen Tools** **Food** Beverages Condiments Other **Toys and Games** For Adults For Children **Apparel** Designer clothing Sweatshirts/T-shirts Socks **Timekeeping** Watches Clocks Calendars **Technology** Software **Office and Desk Accessories** Staplers Calculators Pencil holders Trash cans

*The giftware category is so broad that it may encompass many other items listed elsewhere. Example: Tableware is a separate category but it is also considered to be a gift item.

When you're thinking about products you might design, think about your own life. What do you wish you had that you don't have now? What would be nice to have? What's more convenient than what you already have? Try all kinds of approaches. You won't be successful at everything you try, but keep at it. It helps to keep moving forward. That's what's worked for me.
—Jane Tilka, Tilka Design

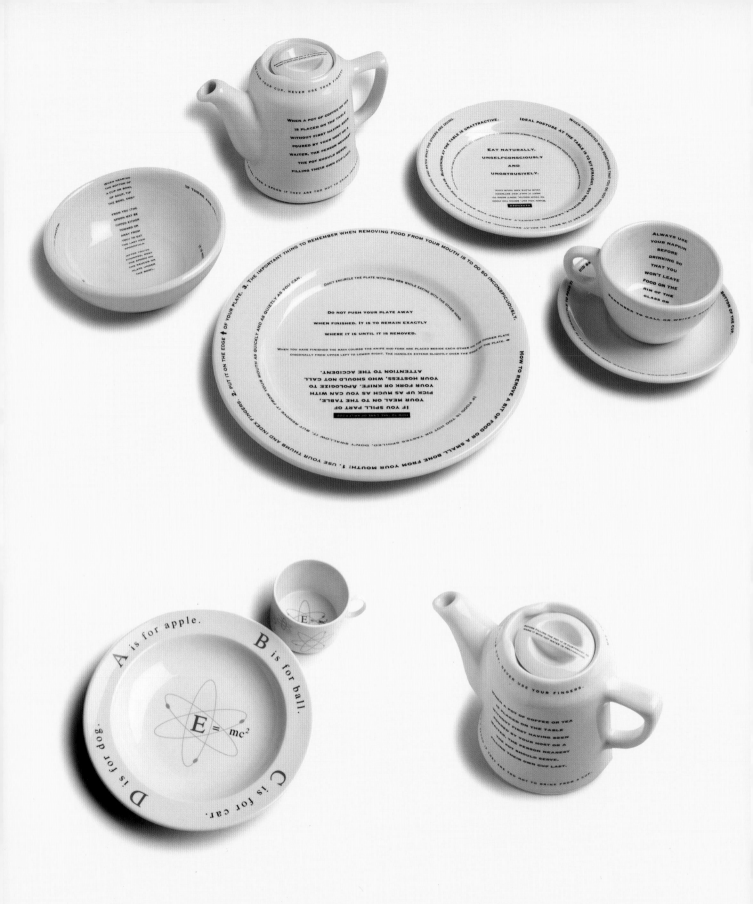

IN THE RIGHT PLACE AT THE RIGHT TIME WITH THE RIGHT PRODUCT

San Francisco's Jane Timberlake designed her "Wild Mannered" dinnerware during her days at Art Center College of Design in Pasadena, California. The assignment: design a graphic set of dinnerware. The night before the assignment was due, Timberlake took some plates from her kitchen and placed typographic treatments of contemporary and arcane rules of dining etiquette on the surface. This incensed her instructor but delighted her peers; many encouraged her to produce them.

It wasn't until years later, after overseeing the visual consistency and quality of Esprit de Corps' international stores that Timberlake decided to take her classmates' advice and make the move into product design.

With prototypes of dishes in hand, she flew to New York, determined to launch her line. The first stop was at Barney's to meet an assistant buyer. The buyer looked at Timberlake's plates and asked if she could take them into her boss. While she was gone, Timberlake's imagination raced. Large orders! Huge window displays! In-store appearances (what would she wear?)! Autograph sessions! Travel!

In the midst of her reverie, the assistant buyer returned. She asked if Timberlake was familiar with what Barney's sells "because these plates are really not us." According to Timberlake, the walk out the front door seemed longer than the flight from SFO to JFK. Timberlake immediately placed blame on her family and friends. They knew my plates were dumb but they encouraged me because they felt obligated, she thought.

Depressed, Timberlake started walking. About twenty-five blocks later she found herself in SoHo at the Guggenheim Museum Store at Broadway and Prince. She didn't have an appointment; on the other hand, she had nothing to lose. She asked a cashier who did the store's buying and was referred upstairs. The buyer met with Timberlake and placed a fifty-set order (one of her largest dinnerware orders to date). The A-1 Product Company was in business. Today, it's the epicenter of a full line of inventive tableware. Wild Mannered Dinnerware was recently purchased by the Museum of Decorative Arts in Montreal for its permanent collection. The experience, reflects Timberlake, was "product design baptism by fire."

Use the following tool for brainstorming. One place to start is to iden-
tify trends. Consider the different ways someone might respond
when their environment changes. What happens in the home? What
about work? At play? What might they need—or want?

Don't feel constrained by this blueprint. Instead, list all the new
product ideas you can think of. Then work backwards. Why would
someone else want your product? What problem would it solve for
them? What trends support your ideas?

Trends	Market Mindset	Opportunity	New Product Ideas
Spend more time with family.	Hard to find things that are portable, practical, work for a variety of ages, in indoor and out-side environments, at home and for traveling.	Portable game that crosses age/gender boundaries. Multi-purpose even better.	Beach checkers! An oversized, square beach towel printed with checker pattern. Game pieces are miniature Frisbee-like disks (may double as flying disks). Set rolls up into tube with easy-carry handle.
No time.	Constantly forgetting things, even birthdays of those I care about. Commercial organizers are ugly and high maintenance.	Low maintenance prod-ucts to help you remem-ber people who are important to you.	Stylish organizer to hang in kitchen pantry with compartments for each month. Sized to hold birthday cards, anniver-sary cards, etc. Comes with a starter set of twenty-four cards.
Lavish corporate gifts are out.	Want to remember important customers and clients at a reasonable price but no trinkets and trash.	Reasonably priced cor-porate gift line.	Fill in the blank yourself.

FACTOR IN YOUR OWN EXPERIENCE AND EXPERTISE

Taking into account your own life and your own experiences is central
to developing products that are viable. This is true for a couple of
reasons. First, you have a greater chance of achieving success if you
create a product you know something about versus something you

hard

work

know nothing about. Do something you know well. Designing a brochure for a client in an industry in which you already have experience gives you insights into that industry that you may not otherwise have. Perceptually, clients are attracted to those that already have experience in a particular area. The same holds true for product buyers. You are an expert who is coming to them with a solution to a problem. On the other hand, you may enter a brand new area with complete objectivity and an open mind, enabling you to see something others before you may have missed. Doing something you know well is not a prerequisite.

However, you will be most successful if you design a product or a product line that you truly care about. All of the benefits of product design come only with patience and plain old hard work. Prepare yourself now. You will probably work harder than you've ever worked. You will probably set new records for nonbillable hours logged. Because the product design process requires such a large commitment of time and energy, do it only if it's something you're passionate about.

patience

DETERMINE WHAT YOU WANT FROM ALL THIS

Before you decide what product you'll design, what markets to consider, step back for a moment and think about what you want to attain over the longer term. Why do you want to be a product designer? Know up front that fame and fortune will probably not come overnight. And success may have less to do with talent and creativity and more to do with being in the right place at the right time with the right product. Still, there is no substitute for tenacity and perseverance.

GET GOING

Once you have an idea or two that you want to explore, you're ready to move forward to the next step.

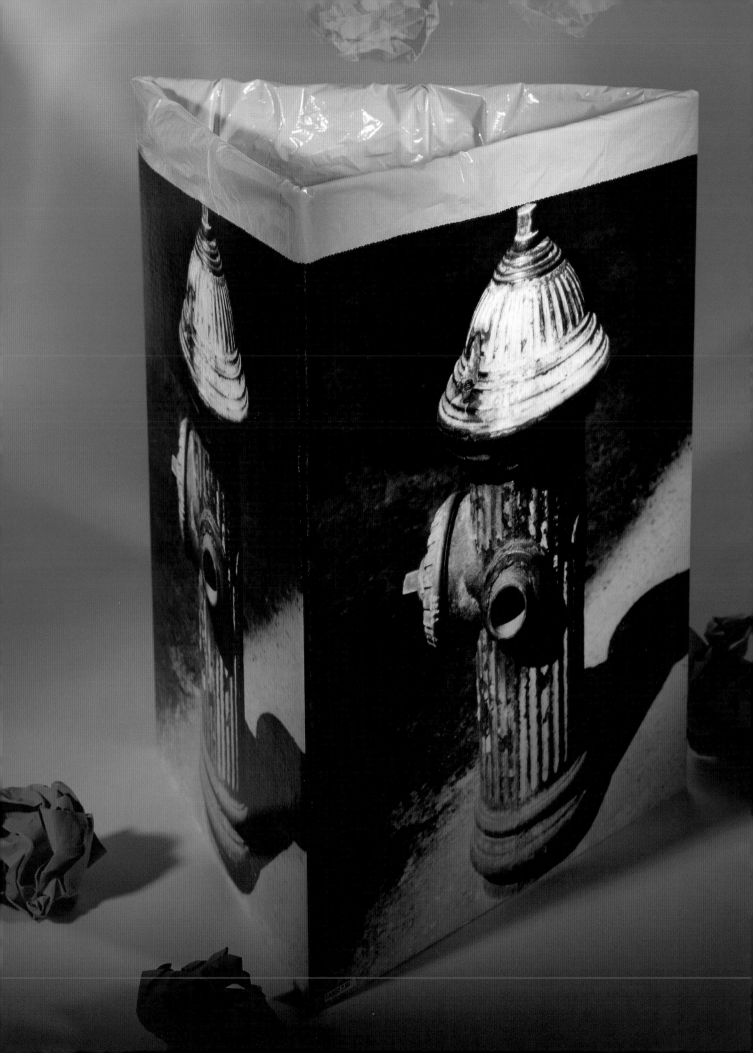

CHAPTER 2

Once you have an idea for a new product, the first step toward making it a reality is to create a prototype, a working model, of your product. The process of prototyping will help you:

(**1**) Make the shift from 2-D to 3-D.

(**2**) Determine what materials might perform best for you.

(**3**) Learn how your product might be manufactured.

(**4**) Anticipate potential problems and avoid costly mistakes.

(**5**) Have confidence that what you think can be done is technically achievable.

(**6**) Create something tangible, enabling others to view and understand your idea more easily than sketches and drawings.

prototyping

START WITH DRAWINGS AND SKETCHES

Drawings or sketches are usually the logical place to start the design process. Initially, loose renderings are appropriate; at this stage, "good" drawing doesn't count. Start working through your ideas. If you're designing a flower vase, you might start by thinking about the attributes that are important to you. Will the vase hold a single stem or an entire bunch of fresh flowers? Will the look be formal or informal? Traditional or postmodern? Transparent or opaque?

THE VALUE OF A JOURNAL

Journal-keeping enables you to archive ideas and maintain records. If you reach a dead end as you're sketching, you might shift into a completely different direction for a time. Coming back to your idea with a fresh perspective may give you new insights on ways to solve a particular problem. Plus, your journal will serve as a springboard for new ideas down the road. If you keep your journal chronologically, you will be able to document the progression of your designs. This will become a record of when the idea was first developed (see "Copyright" in chapter five).

KEEP A JOURNAL

While you're drawing, sketching and making notes, keep a journal. Most product designers keep some type of journal or notebook to jot down thoughts and ideas; this will give you a single place to record product ideas as they occur to you.

CREATING PROTOTYPES MAY LEAD TO DISCOVERY

Once you have a visual direction you want to explore further, start making models. Ideally, you'll employ the materials you'd like to

utilize in the finished production. Though you may begin with a sketch, you may find that the materials themselves take you in an entirely new and unexpected direction.

WORK BACKWARDS AND GET TO KNOW YOUR MATERIALS

The notion of working hands-on with materials early in the design process is not typical of a traditional industrial design process. Computer-aided design (CAD) systems may be used to render products (e.g., a car or computer housing). Prototypes come later. This is due perhaps to the fact that assignments are often complex, highly technical and expensive to prototype. That's generally not true with the types of object-oriented products shown throughout this book. In fact, the more you know about the inherent strengths and limitations of the materials you plan to use for your product—and the earlier you start working with materials—the further you can push the boundaries of possibility. Many designers, such as Michael Cronan, advise you to "learn as much as you can about the materials…and then go design."

PROTOTYPE ASSEMBLY AND CONSTRUCTION

Not only will prototyping help you understand the materials you specify, it will help you fully understand the processes involved in manufacturing and assembling your product—before you're too far along to make changes. This can help you to avoid costly mistakes.

PROGRESSIVE MODELS AND PROTOTYPES

The process of prototyping varies greatly depending on the type of product you're designing, the level of complexity, the type of materials required and how you plan to go to market (for more information see chapter four). The case studies in this chapter show how different designers handled a range of products utilizing a variety of unexpected materials.

HELPFUL DEFINITIONS

A **model** is a three-dimensional form of a product. A model may be loose, as in a "sketch model" or mock-up. Or it can be a "hard" or "finished" model which, if photographed, may be indistinguishable from the real product. Models may be done to scale or to size. In industrial design applications, modelmaking is an art in itself.

A **prototype** is a finished, usually one-of-a-kind sample of the product. It is the final version of the product before it is made or manufactured in quantity. If the product has moving parts, the prototype has moving parts. It is used as a point of tangible reference for the final dimensions that will be needed for production.

Source: Professional Modelmaking, Norman Trudeau. New York: Whitney Library of Design, 1995.

WHAT LEVEL OF FINISH?

The purpose of your model is paramount to how you construct it. The level of finish required for your model or prototype largely depends on your own needs and how you decide to go to market (see chapter four for more information).

If you plan to market the product yourself, a prototype with a high degree of finish is desirable. For example, you may need a finished prototype to show buyers at a trade show. Even before that, you may want a prototype to show in order to get feedback from potential customers and/or the trade. A prototype might also be useful to enlighten manufacturers from whom you intend to source materials, labor or supplies.

If you choose to license the product to someone else or to work with a manufacturer on a royalty or work-for-hire basis, you may not need more than a simple drawing or sketch; whatever will enable you to quickly and accurately convey your idea. This depends upon the needs and level of sophistication of the licensor (see chapter five for more information).

One day, armed with a glue gun, dowels and cardboard, designer Giovanni Pellone set out to generate some ideas for furniture. After hours of work, he stepped back and stared. No matter which way he looked at his sketches, "nothing worth an exclamation point seemed to emerge," he recalls.

Meanwhile, the floor was littered with scrap material in all shapes and sizes. Defeated, Pellone pulled out a trash bag and began cleaning up. A large folded piece of cardboard seemed worth keeping. He propped it up and used it to support the plastic bag while collecting the last pieces of scrap from the floor. Pellone stepped back and stared again at the folded, triangular piece of cardboard standing in front of him. The cardboard had become a wastebasket! A new product was born.

ZAGO™ is a folding trash can with three sides made from recycled paper waste. Cost-effective and durable, ZAGO comes with three standard-sized trash bags and is available in a variety of patterns and sizes to meet different aesthetics and environments. The low cost ($3.50-$7.50 wholesale) means that virtually anyone can have a designer trash can. It is manufactured and distributed by Benza, inc., the product design arm of Pellone and Means, an interdisciplinary design firm in New York City.

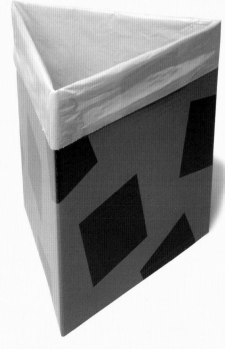

USING OUTSIDE SOURCES VS. DO-IT-YOURSELF

If you don't have access to the equipment, materials or skill needed to create a prototype, you may need to get outside help. If this is the case, you might engage the services of a firm that does nothing but make new product prototypes (see chapter twelve for more information). However, this can become a costly proposition and may not be a necessary investment. If possible, do it yourself. If you need to source one or more components of your product, the best place to start is generally with manufacturers of the materials you desire (see chapter six for more information).

THE TEST OF TIME

Be sure to consider material durability. For example, will colors fade in direct or indirect sunlight? Will metals tarnish in an unsightly manner? Will fingerprints show? Will machine scores crack? Will die-cuts tear? Will paper bend or bow? Will perforations tear properly? Will the adhesive hold? What impact will light, air, temperature and other external conditions have on any material you specify? Leave enough time in the prototyping process to ensure you have the answers to questions like these.

THE INHERENT VALUE OF PROTOTYPING

Even if you think you won't need a prototype to show to a prospect, a manufacturer or a potential customer, it doesn't mean that this step should be overlooked. The process of making models is invaluable. The shift from 2-D to 3-D will enhance your visual and perceptual skills. Additionally, prototypes will enable you to study such things as highlights, reflections, finishes, grain direction and surface textures. Prototyping is useful in demonstrating the potential emotive impact of your work. Finally, the act of making things, can lead to discoveries—and other product ideas—you otherwise might never have imagined.

PRODUCT PLANNING AND PROTOTYPING CONSIDERATIONS

Material Integrity

Do the materials selected offer the integrity you desire?

Do they feel right?

Do they provide the look you intended?

Environmental

Are there environmental issues you need to be aware of (e.g., toxins in the manufacturing process? lead in paints? etc.)?

Material compatibility

Do the materials you've specified combine the way you thought they would?

Material availability

Can the materials for your product be readily purchased from existing sources of supply?

Assembly

What is required to assemble the finished piece?

How much time will each product require for assembly?

Will the assembly require skilled labor? What kind of training will be necessary?

Where could the assembly be done?

Color

Is color matching critical?

If you have more than one material or substrate, will you be able to match color as you desire?

How will you achieve consistent color from run to run?

Durability

Who will use the product?

What is its intended life?

How do the materials respond to external conditions such as light, temperature, etc.?

Manufacturing

Can your product be created using existing equipment/sources?

Will it be hand-assembled or machine-made?

Will you need to invest in special toolings or dies?

Weight

What will the finished piece weigh?

How much will it cost to ship?

Tacked to one wall in a workroom in the South End of Boston's Studio F. kia is a yellowing page, torn from a magazine. It says "Whoever wants to know a thing has no way of doing so except by coming into direct contact with it....All genuine knowledge originates in direct experience." (Mao Zedong, "On Practice," in *Selected Works*, 1937.) Unfortunately, Marcello Albanese and Gary Knell learned this lesson the hard way.

When designing their whimsical, stainless steel spring toothbrush holders, they decided that cast resin would provide the perfect base. They chose resin for its appeal, color and distinctiveness. At the time, they had no specific knowledge of the substrate's properties or its limitations. They made early models themselves using jeweler's wax (because it's easy to work with), clay and wood. They took the models to a specialty resin manufacturer.

The meeting was disastrous. The principals of Studio F. kia hadn't understood the complexities inherent to cast resin—such as the type of molds required, the effects of severe temperature changes in the production process and other limited stress parameters—and they were told their prototypes were impossible to produce. If they wanted to use resin successfully, they would have to know more about it (see "Progressive Models and Prototypes" in this chapter).

Not only did Albanese and Knell discover that you need to know how materials can be formed and shaped, they also discovered that you need to think about how materials will perform over time. A second supplier was retained to create the springs that would ultimately serve as the holder for the toothbrushes. Drawings were provided and initial production samples were made. At the New York International Gift Fair, buyers received the product enthusiastically. Orders were taken and filled. Within weeks, mail started pouring into the studio. Unfortunately, it wasn't fan mail. The wire Studio F. kia had specified for the spiral base was "coated." What they didn't know was that coated didn't mean rustproof. The toothbrush holders were corroding.

They rallied back quickly. Buyers were contacted immediately. Defective product was replaced. Studio F. kia's quick response probably saved them from irrevocably tarnishing their reputation with the trade.

From this experience, the designers found that having a knowledge of materials is essential to success. They now spend a good deal of time researching material capabilities before they begin designing. They're not afraid to specify new materials, but now they ask more questions of suppliers and they attend manufacturer trade shows. After three years (a pretty long life for a product in the giftware industry), Brush Up, the name for their innovation, remains the studio's number one-selling product.

Sandra Higashi and Byron Glaser, principals of one of the most prolific graphic-design-turned-product-design firms in the U.S., want to be "in every room in the house." In less than six years, this design team has designed and marketed more than twenty separate products under the brand name Zolo. Their line of organic and geometric pillows represents the team's first entree into home furnishings.

(1) *Sketches were the first step. Renderings were sent to a supplier who was very cooperative and "amazingly creative." Anxious to form an ongoing alliance, the supplier was willing to stick his neck out. Colorations of raw silk and lush velvet fabrics were specified using the Pantone® color matching system.*

(2) *Within several weeks, patterns were directly translated into pillow forms by the manufacturer. The objective was to analyze the shapes. The early result was an enormous disappointment; first-round prototypes were nothing like they had imagined. The early models helped Higashi and Glaser better understand the limitations of foam. They had created curves that were too complicated to produce.*

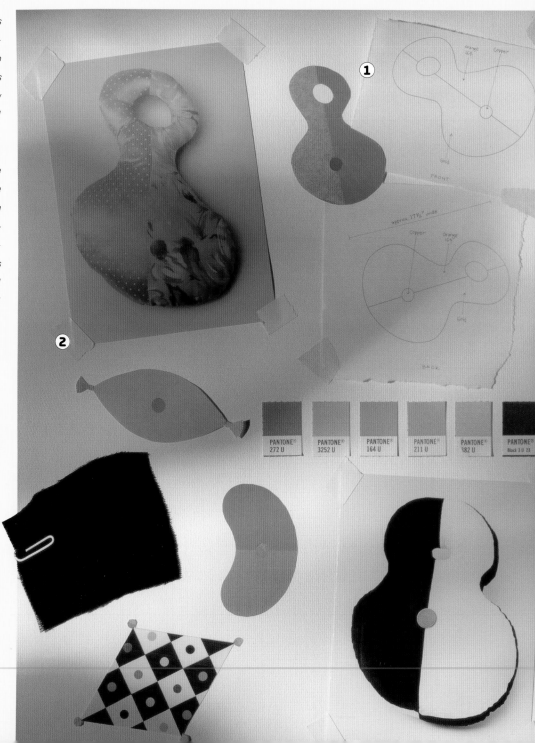

At a trade show, they adorned their booth with handmade furniture fashioned from cardboard and black electrical tape. The idea was to show their products, mostly for the home, in context. A friend, hoping to launch a new manufacturing company stopped by, saw the furniture and suggested that together they might create "Zolo-esque" type pillows. The timing seemed right.

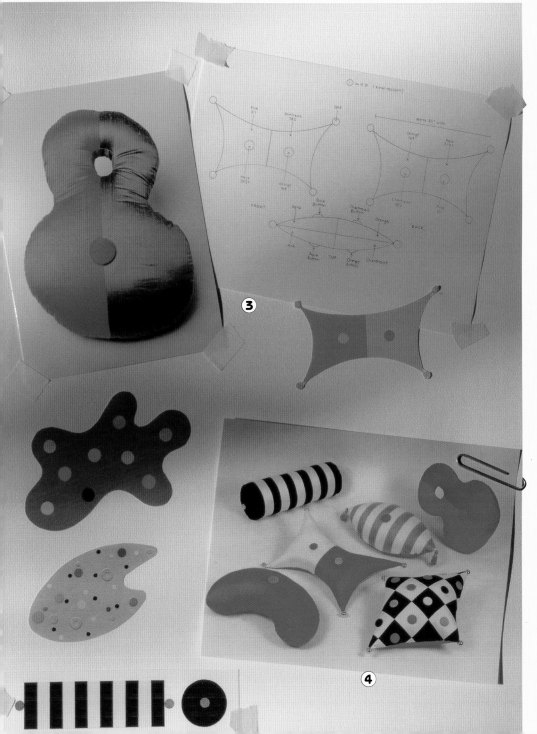

3 Additional renderings were created to fine-tune pillow shapes and sizes. Custom-dyed fabrics were created and 24-karat gold-plated balls were sourced. The balls were ultimately crafted by a jeweler. Fabric-covered buttons were prototyped that would adorn the finished creations. Higashi and Glaser were very close to a key trade show, and wondered if they should leave space for the pillows. Luckily, Higashi says, "the second round was hopeful. They got it! Our supplier had made a tremendous leap forward."

4 The initial lineup included six shapes. "We had to flatten out a lot of the curves. There's only so much you can do with a sewing machine," says Glaser. Pillows ultimately had to be made by hand. The log, a more traditional "neck roll" shape, is their early best-seller. They're not surprised. "It's closer to a more 'accepted' pillow," she adds.

Gary Knell and Marcello Albanese collaborate closely in the early stages of designing a new product. One might start drawings and sketches; the other then expands on the other's initial ideas. That was the case with the development of Brush Up. Carried today by gift stores across the U.S., Brush Up promises to keep your dental duties lighthearted. The line has been featured in a number of leading design magazines such as *Elle Décor*.

1 The idea for Brush Up was inspired by a visit to a friend's home. In the bathroom, a toothbrush rested in a sculptured form on the counter. "I don't know if it was designed to hold a toothbrush or if it was an accident, but we thought it was a great idea," says Albanese. From there, he began sketching in his journal.

2 Initial ideas were shared with Knell. From there, Knell developed the idea of a spring-type form to hold the brush.

3 At this point, both played with different base shapes and configurations.

4 The idea of working with resin was appealing. It was popular, relatively inexpensive and offered interesting colorations.

5 Gift industry sales reps advised the pair when creating a new line to "do threes and fives—do everything in sets of three or five," says Knell. Both laughingly say they still don't know why that's the case. But they decided to develop three versions of Brush Up. Meanwhile, they brainstormed a variety of product names such as Stick It, Hold Up and Hold It.

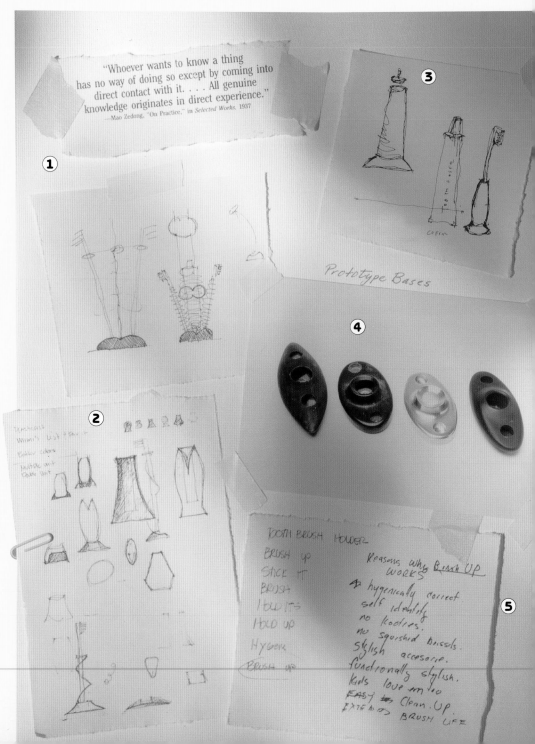

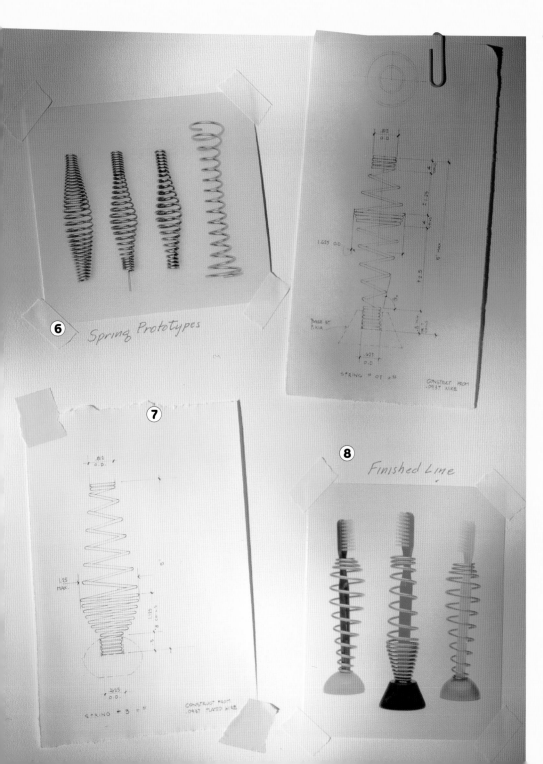

6 Spring Prototypes

7

8 Finished Line

6 Early versions of the resin bases were created by the team themselves. At this point, they also experimented with different bases (one idea was to create a base with a suction cup). Normally, the manufacturer would make them but "he wasn't coming through and we had a deadline," says Knell. In this sense they were fortunate because this enabled them to get inside the manufacturing plant, do it themselves and learn a process they otherwise would not have been privy to. It was only through this unplanned opportunity that they were able to learn enough about the process to design bases that worked.

7 Technical drawings were created for the spring toothbrush housing. As architectural school graduates, they had the technical expertise to do engineering-type renderings themselves.

8 The finished line includes single, double and family-sized versions. The single Brush Up is offered in three shapes and eight colors. The product concept has been so successful that the design team is already working several line extensions using different base materials such as machined aluminum. As one retailer put it, "They're imaginative, witty and fun."

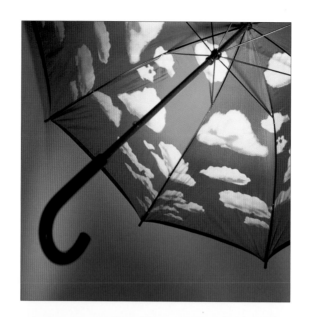

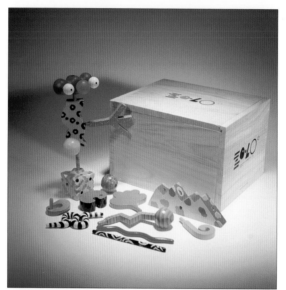

when to consider making a prototype

Some products require a dimensional model to express a complex idea or to convey an emotional element that would otherwise be missing. "Certain concepts you have to see to really understand," says Ruth Shapiro of the Museum of Modern Art (MoMA) in New York. Emanuela Frattini Magnusson came to the museum one day with a couple of umbrellas. She opened one up. "We saw the sky inside," Shapiro recalls. The demonstration convinced MoMA to get behind the product. Would drawings have sufficed? Maybe. But maybe not.

When Byron Glaser first brought the prototype of his and Sandra Higashi's imaginative play set, Zolo, to the Museum of Modern Art, buyer Ruth Shapiro was amazed. "He opened up a wood crate and started pulling out these hand-painted curlicues, twisted things, brush heads…and made all these animals and people walking around the desk. It was really fabulous." The prototype convinced the museum to make an investment in the idea. The prototype paid off. Over time, MoMA sold more than ten thousand units.

If your design is two-dimensional, a prototype may not even be necessary. Jane Tilka, principal of Minneapolis-based Tilka Design, has an ongoing relationship with a number of licensors including catalog operations and greeting card manufacturers. She and her design staff spend virtually no time on prototyping. "We're not creating something that's never been created before," she notes. In designing T-shirts or gift tiles, for example, she says a prototype isn't necessary. "The T-shirt exists. The tile exists. It's easy to visualize the finished result."

A recent survey revealed that four out of five designers turn varying shades of PMS 584 when they hear the word research. But gaining market intelligence and obtaining customer feedback are important aspects of the product design process. Both types of research will help you elicit information concerning attitudes and potential buyer behavior toward your product.

Contrary to what you might think, the research you'll require need not result in mountains of paper nor does it necessarily require the expertise of a market research firm. In fact, most of the initiatives suggested are ones you can undertake yourself; the biggest investment you make will be the time you spend.

Different types of *market* research (information-gathering about a specific market or geographic area) and *marketing* research (gauging attitudes and reactions) will be useful to you at different points in the product design process. Your findings will help you refine your ideas and make your designs more potent. The process itself can often be not only enlightening but even fun.

You will want to consider research during each of these design phases: (1) pre-design—before you start designing; (2) during design—while you're developing ideas; and (3) pre-launch—prototype stage.

PHASE I: PRE-DESIGN RESEARCH

While you're sketching new product ideas, you'll also need to learn about the dynamics of the market you intend to enter. At this point, you should start by reviewing secondary research (see "Different Types of Research" in this chapter). The purpose is to uncover information about the industry you want to enter. Who are the key players? What products are most successful? How does the industry

work? For some searches you will need to know the *Standard Industrial Classification* (SIC) code of the industry you're targeting. This coding is an accepted method of categorizing industry types. Ask your librarian for the *Standard Industrial Classification Manual,* usually at the reference desk.

Product Information

Most companies offer literature and most have a presence on the Web. Call companies directly for information or visit their Web site. This is also an opportunity to communicate by E-mail with the manufacturer of any product or service you are interested in.

Competitor Information

Visit competitor Web sites for information on their product lines, pricing, positioning, sales strategy and services. Or call for information.

General Business Information

Use any of the search engines on the Web to obtain information on practically any subject you need. All you have to do is find one promising Web site and go from there. One of the most promising Web sites is the Edward Lowe Foundation's smallbizNet. Created to assist entrepreneurs and small business, it offers much information of a general nature on topics ranging from associations to industry-specific information to purchasing and supplier relations. The links, called "hailed sites," are updated regularly. Links include the U.S. Census Bureau, U.S. Department of Commerce and the Bureau of Labor Statistics. To access: www.lowe.org

Whether you search on-line or at the library, make your hunt as productive as possible. Try to narrow down your topics. Secondly, be creative about how you conduct your inquiry. For example, if you are designing a chair for an office, you would not want to limit yourself to seeking information on "chairs" and "furniture design." You might also look into "ergonomics," "growth in the home office" and

check out web sites

"It's very hard to produce good work. Successfully bringing a new product to market takes a tremendous amount of time, work, energy and money—along with coordination, skill and luck. That being the case, you should work on things you really care about."

—Adrienne Pollard, Pollard Design

WANT A QUICK WAY TO ACCESS TRADE SHOW INFORMATION?

Check out these on-line sites for dates of upcoming trade shows. You don't have to know the show name to find information on it. For example, Trade Show Central lets you search by show type, industry and country.

Trade Show Central—www.tscentral.com

Expo Guide—www.expoguide.com

Trade Show News Network—www.tsnn.com

"interior design trends".

Librarians can also be helpful and they can save you a lot of time. When you go to the library, make friends with the reference librarians. Also, don't forget that you can call the library to ask specific questions such as "Where can I find a list of last year's top-selling toys?" The reference librarian will help you find precisely what you need through reference tools like *The New York Times Index*, *F&S Index*, CD-ROM-based information retrieval systems and the H.W. Wilson Subject Indexes to name a few.

USE PERSONAL NEWS SERVICES

One of the most exciting aspects of the Web is the advent of services that automatically search on-line news sources for articles that match your area of interest and deliver them to you as E-mail. This is an easy way to put your computer to work while you're doing other things.

My Yahoo!

This product line extension was created by the originators of Yahoo!, one of the most popular search engines on the Web. The service enables you to build your own newspaper and it's updated continually for you. You can get current business news from more than forty industries, indexed by company. To access: www.my.yahoo.com

News Profiles

America Online (AOL) subscribers can use a feature called "News Profiles." This enables you to search AOL's news sources by topic and by source. Articles are sent to you throughout the day.

PointCast

This is an Internet news network that takes news directly off the Net and delivers it to you. You specify how often you want it updated. Sources include the *New York Times*, *Los Angeles Times*, Reuters (newswire), PR Newswire, Business Wire, and *People*, *Time* and *Money* magazines. To access: www.pointcast.com

yahoo

GET INFORMATION ON SPECIFIC INDUSTRIES

Trade publications, buyer guides and trade shows are good places to gather information on a particular industry. As you read the descriptions of the articles available from the various indexes, note the source publication. This will often provide you with a guide to leading trade publications you can then contact for more in-depth information. To find out more about trade shows, consult the *Directory of Conventions*, a book most libraries have, or ask people in the industry. You might also try IndustryNET, a free Internet offering where manufacturers can log into a network that provides access to chat groups. To access: www.industry.net

DEVELOP A MENTAL IMAGE OF YOUR CUSTOMER

During this phase, you should identify your customer. Define customers demographically and psychographically. Demographic considerations include age, sex, income level, marital status, ethnicity, geography and education. Psychographic/lifestyle considerations include a person's activities, interests and opinions. If you're designing a niche product, remember that your intuition counts.

GO SHOPPING

Go to the types of stores you think are most likely to carry your product. What does the store look like? How does the store present its products? How do sales associates interact with customers? What kind of customers shop at the store? What are the customers buying? Are they buying for themselves or for someone else? Who are the buyers for the store? What kind of things are they looking for?

In some industries retail outlets are the last place you'd want to go. Michael Vanderbyl, principal of San Francisco-based Vanderbyl Design, says that furniture generally seen by the public in traditional retail outlets is a small look at what's out there. In this case, try design centers, marts or to-the-trade showrooms.

HOW TO GET THE MOST FROM YOUR ON-LINE SEARCH

You need to understand how various services find information in order to get the most from your search. Each information retrieval system works differently, but in general:

If you conduct an on-line search asking for credit card companies you will get thousands of listings that relate to credit, card and companies (but they may not necessarily connect the three words). Therefore, you should include the word "and" or the plus (+) sign when you request information. Be sure to leave no space between words or characters. Example: credit+card+companies. Additionally, make your request as specific as possible. Do you really want a list of credit card companies or do you want to become a credit card merchant? If so, become+credit+card+merchant is a better way to search for the specific information you need. More words are generally better.

Just as you can use "+" and "and" as connectors, you can use a minus sign (-) before words you don't want. For example, if you want a list of all gift stores in the U.S. except in three states, you might request: gift+stores+ US-Alaska-Hawaii-Florida. And, just as the plus sign must connect the words together, the minus sign is placed immediately before the word you want to exclude as in: -Florida not Florida-. Are you totally confused? Try it. You'll see.

OBTAINING CUSTOMER FEEDBACK IS CRITICAL

Created by San Francisco designer Michael Cronan and Karin Hibma, Cronan Artefact's Walking Man clothing line garnered praise from square one with an *ID* magazine gold award for its "quality, good looks and remarkable flexibility." These threshold marketers had conceived of a new way to think about clothing. They created a line that literally fits well and helps you fit in, with styles that can easily take you through the day and on into the evening. In fashion, one size does not fit all and as sizes increase, they quickly learned, patterns are not necessarily proportionate.

Once their first prototypes were made by a local seamstress, they invited their friends, mostly designers, to act as fit models for the clothing. "Designers are the pickiest people," says Cronan Artefact president Karin Hibma. "They had absolutely no hesitation in telling us what was wrong with the things we were doing."

In retrospect, this was a smart way to test their concepts on an audience they hoped would ultimately embrace them. They felt their concepts would appeal to those whose minds favor the complex but who ultimately like to keep things simple. "The best thing you can hear," claims Cronan, "is why something won't work, why it's terrible or why it's a completely idiotic idea." Cronan says he goes to the toughest people he can find and listens to what they have to say.

Research doesn't have to be formal and its value is increased when it's done over time. Vice president of operations Mary Coe keeps a Walking Man wish list. Anytime a customer says "Oh, I wish you would make a…" Coe passes along the information to product development. Additionally, customers' sizes and preferences are recorded and tracked. It's expensive and time-consuming, but Hibma, who oversees and manages every aspect of the business, notes that their brand isn't a fad. "I'm a gardener," she says. "I'm used to nurturing things over the long-term."

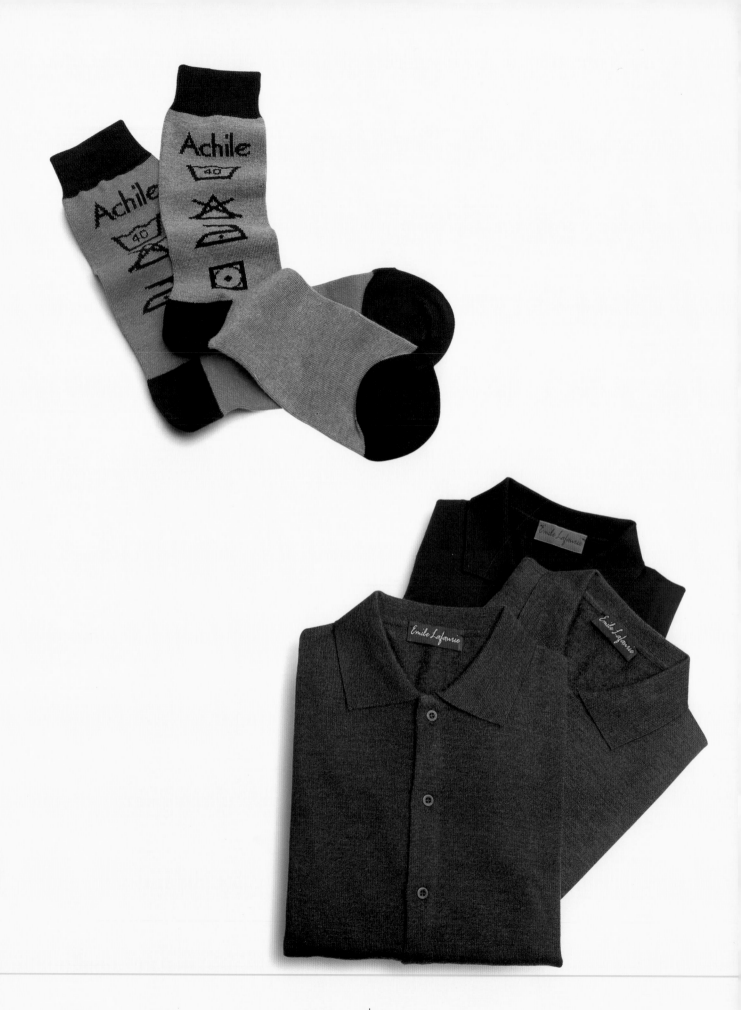

JOHN CLARK DOES MARKETING RESEARCH BY THE SEAT OF HIS PANTS

The owner of *Clark's Register*, an upscale apparel and accessories catalog for "men of the world who want menswear they can't find any place else," sits in airports and watches passersby. "When you're waiting for a flight, you see the march of humanity," says Clark. "Frequent air travelers are the ones with the instinct and the means to make $100 impulse purchases." That's the customer Clark is after.

Clark travels a good deal for his graphic design practice and finds himself in airports nearly every week. He looks for what his prospects have, what they don't have, what there's too much of and what "makes a guy stand out in a crowd." After four years, Clark has found that his American customers admire and desire a European edge. "That's what I'm trying to get at and it's not a big market. If I can find 2,000 customers that spend $1,000 a year with me, that's a nice little business. You don't need a lot of people, you need the right people."

Much of his product design knowledge is based on his experience as a graphic designer. Early in his career, Clark created advertising for Gant, a menswear manufacturer, and later found himself consulting on garment design. He earned a position in clients' minds as someone who could create the look of a line, not only in the way it's presented vis-à-vis packaging and labeling, but also in the actual design of the garments. He could conceive of the collections as both a product and a presentation. As his business grew, he went on to design a number of mail-order catalogs for houses like Laura Ashley and Garnett Hill.

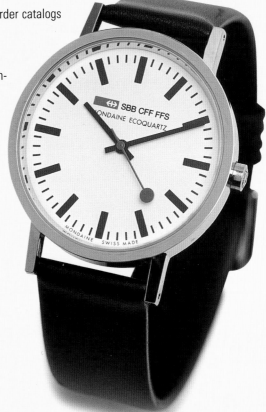

Clark's technique may not follow prescribed marketing research methods, but he's successful nevertheless. And he's done his market homework. "There are 419,000 households that are in the right income category for me, ones that spend more than $3,000 per year on clothing. When I get 1% of that audience, I'll have a very nice business."

By now you should have tighter drawings or sketches and perhaps a prototype. It's time for a reality check. At this point, you should start gathering even more information.

Get feedback from customers

Showing your ideas to potential customers is one of the most important tools you can use. Think of this as guerrilla research. Get into the trenches with your customers. What do they like? What don't they like? Do they understand what the product is? How would they use it? When would they use it? Would they buy it for themselves? Would they buy it for someone else? How much are they willing to pay for it? Does the product meet a previously unmet need? Why or why not?

This information-gathering process may be conducted in a variety of ways, but if you have the time and inclination, in-depth, one-on-one interviews will offer the most insight. In-store interviews are also good if you can get permission from the store owner. Nothing will replace personal interaction; but as a supplement, if you have your own Web site or know someone who does, consider on-line research. Post an image of your product and solicit opinions. Make sure the feedback is coming from the kind of customer you're targeting.

Get feedback from the trade

Many product designers know that they should talk to potential customers, but unless you're selling your product direct, other gatekeepers such as buyers, sales reps, wholesalers or distributors will be involved in the selling process. If "the trade" doesn't respond to your ideas, your product might never see the light of day. Therefore, it's wise to preview your idea with them. Talk to buyers first. Do they think they can sell it? Who do they think would buy it? How would they display it? What do they think the product is worth? How much would it sell for?

Believe in your product. You have to do something you just can't live without. That's what keeps me going at 4 A.M. when I just sit there filling orders.

—*Jill Harris, Canyon Design*

WANT TO FIND OUT THE LATEST COLOR TRENDS?

The Color Marketing Group is an international association that forecasts colors for manufactured products ranging from cars to carpets, wallpaper to toys, fabrics and fashions to electronics. This organization has a wealth of information and provides members with regular color updates and a newsletter called "ColorChips." You must be a member to receive them. (For more information, see "Associations/Industry Related" in chapter twelve or www.colormarketing.org on-line.)

The name Yaza sounds like a yelp of joy. In fact, it is the name of a Cambridge, Massachusetts-based company run by Jane Winsor and Stephanie Logan. Yaza designs, markets and manufactures whimsical gifts, wraps, blank journals, high-end photo albums and other miscellany.

The two childhood friends started their company in the early 1990s with a desire to produce environmentally thoughtful products. Combining Winsor's graphic design and illustrative talents with Logan's marketing savvy, the team invested months developing their initial product offering, a recycled gift wrap line. When it was complete, Logan contacted sales reps around the country. She wanted them to preview the line in hopes of later convincing them to take on the line for national distribution.

The reps looked at the wraps. Their reaction was simple and took Logan totally by surprise. "What? You call this a line?" they screamed. As it turns out, six items didn't constitute a substantial offering that reps would even consider taking to buyers. A couple of the reps took Logan and Winsor under their wing, offering advice and encouragement. Winsor created more patterns. Problem solved. The reps loved the new designs and took on the line.

Informal research now helps to set a clear direction for all of Yaza's product design initiatives. Previewing ideas with the trade has become a matter of course over the pair's five-year history. But Winsor cautions that it's easy to "hear what you want to hear" and warns that in her experience, one must talk to consumers or to buyers that you don't already know.

"Sell-through is everything," Winsor says. Their playful Cucci Coo line of baby T-shirts and bibs, packaged in real baby bottles, were enthusiastically received by their sales reps and buyers. But the line hasn't performed to Yaza's expectations at the retail level. "People you know don't want to hurt your feelings, so asking your friends is no good," counsels Winsor. "Go to the people who will make the decisions…it's when money is on the line that you'll get the real answers you need." Winsor likes focus groups but says "they should always be blind." In other words, the respondents shouldn't know who the sponsor is. Or, she says, do informal, one-on-one interviews with customers. Finally, she says, "Get as close as you can to the customer. Sales reps are OK, buyers are better, but the customer is who you really want to hear from."

Your product is designed and it may be in the final prototype stage. You're thinking about the packaging of your product. It's time to find out if the presentation of your product enhances its appeal.

Determine the overall product presentation

How will your product be presented in-store? Will it be displayed? Will it be taken out of the package? (Some products in the giftware and home furnishings categories do not need product packaging because the product is displayed so the customer can see it; other products demand it.) How will your product look on the shelf among other products? Will customers understand what it is?

One of the best ways to test this is to make friends with the owner or manager of a retail store that is representative of the type of store you hope to sell to. Ask them if you can come in for an hour at the close of the workday or early one morning. Place your product on the shelf. This will enable you to see it in context. Does it stand out? Does it get lost?

Test the packaging

If your product will be presented in its package in the retail environment, make sure your packaging attracts customers and clearly communicates what your product is. You can test the packaging by mocking up several packaging ideas.

If possible, conduct on-site, in-store research. With permission from a retailer, place your product on the shelf, in its package. As customers meander through the store, ask them questions. Which package first caught their eye? Did your package catch their eye? Why? Why not? What do they think the product is/does? How much would they expect to pay? Would they buy it?

The best market feedback you can receive is a negative critique.
—Michael Cronan
Cronan Artefact

DIFFERENT TYPES OF RESEARCH

Primary research

Information gathered firsthand for the proprietary use of an organization. It is developed specifically to meet the needs of the company or organization conducting the study. Another variation of primary research is syndicated primary research, usually conducted on behalf of more than one company where all participants share in the development of the research methodology and in the cost.

Focus groups

The most frequently used method of qualitative research. Seven to ten people are led in a discussion by a trained moderator. Participants in the group share common characteristics (age, sex, occupation or psychographic trait).

In-depth interviews

A loosely structured interview conducted with one (one-on-one), two (dyad) or even three (triad) people at the same time to obtain their views on a particular subject. One-on-one interviews are most frequently used. The interviewer starts with a list of questions which are often open-ended. The purpose is to probe as much as possible and to "get underneath" buyer behavior.

One-on-ones

An interview technique which might be utilized at the in-store level to find out consumer reaction to products. Questions may be open- or closed-ended and should be designed to elicit specific information about interest in product, intent to buy and pricing.

Surveys

Often conducted over the phone or by mail. Generally include closed-ended questions and questions which are formatted in easy-to-answer ways such as multiple choice, rankings, ratings, yes/no, etc.

Mall intercepts

Conducted where the buyer is actually making purchase decisions. Frequently conducted to elicit buyer response. Usually closed-ended.

Secondary research

Information available to the public, often free of charge, through libraries or on-line.

Giovanni Pellone and Bridget Means were in for a huge surprise at the first trade show they attended in New York City.

Their booth was full of samples of their first product, ZAGO, a folding trash can made from cardboard (see additional photos in chapter two). Pellone and Means thought the product was extremely explicit and easy to understand. The first buyers came around and asked questions like, "Where's the product?", "Why are you only showing the boxes?", and "Can I buy that miniature fire hydrant with a gold or chrome finish?" One buyer thought the product was nothing more than "a box with no bottom."

This potential mishap turned into valuable marketing research. The team learned that "the hardest part of introducing a new and innovative product to market is educating the audience," says Pellone.

But Pellone's unique angle on the design of a trash can had created a vexing marketing challenge. How would Benza educate a vast network of national retailers quickly and affordably? Benza undertook an extensive and aggressive public relations campaign. The goal? To get photographs and information into the hands of as many editors and writers as possible. The rationale? If Benza could obtain placements in leading consumer and trade publications, buyers would see what the product was about. The result? Pick-ups in magazines like *Metropolis* and *Graphis*. "Now they know who we are before we call," says Pellone.

ESSENCE
du mer

CHAPTER 4

There are essentially two paths you can take to bring your product to market. Broadly speaking, you can manufacture and market the product yourself or you can license your idea to someone else who will do it for you. The direction you choose depends upon a variety of factors, such as your level of motivation, your interests, your skills as well as your financial resources and needs. Sometimes the dividing line is the difference between whether your product is two-dimensional or three-dimensional—the level of complexity of your product will likely enter the equation. The most important question to ask yourself is "What do I want to get from all this?" Do you want to spend the majority of your time designing products? Or are you ready for the challenge of starting a whole new company?

market

entry

options

DOING IT ON YOUR OWN

Designing is only one small part of the work you'll do if you decide to take your product to market yourself. One of the motivations for shouldering the responsibility of manufacturing and marketing your product is the desire for control. Not only do you want to design the product, you want to specify the materials that are used for your product and decide who they're purchased from. You want to control how your product is made, how it's priced, how it's sold, where it's sold, who it's sold to and how it's presented in the selling environment. You may want to create a brand.

There are at least two other reasons you might want to take your product to market yourself. First, your product might not be a good candidate for licensing (see chapter five for more information). Second, if you are creating a whole new product category, you may have no choice but to market the product yourself.

Licensing, versus taking a product to market yourself, keeps you free to design 100% of the time. The other compelling advantage to licensing is that other people invest their money in your idea. There's no risk and no cash outlay.

When you enter into a licensing agreement, you grant a party the authorization to use your product design for a specific purpose for a defined period of time. If you choose this option, you will be directly responsible for product design and protecting the product idea.

Your involvement in other critical areas such as product manufacture, quality control, marketing, advertising, etc., is contingent upon the terms agreed upon by you and the licensee (see chapter five). See the comparison chart on page 48.

FROM A BUYER'S PERSPECTIVE

Ruth Shapiro has been buying, selling and producing products for fifteen years. She presently heads up the Museum of Modern Art's (MoMA) wholesale, retail and catalog merchandising operations. Shapiro says the direction you choose depends on who you are, what your interests are, what your level of commitment is to your product, and what you want your level of involvement to be.

She recalls a number of designers who submitted designs to MoMA that were very successful. "As time went on they decided, 'This is a great idea. I'm doing these cards myself. They're really easy. I can go to the printer. I can go on the press run. I'll get a booth at the Stationery Show. I'm in business!' And the next thing you know they have a big line of cards: twenty, thirty, fifty and it goes on and on. Then I run into them two or three years later at a show and I'll say, 'How is it going?' And the reaction is, 'I can't stand it. I'm in the greeting card business…How did I get into this? I want out.' "

The best thing about licensing is you do not have to invest a large amount of your own money up front.
—Peat Jariya
[metal] Studio Inc.

MARKETING THE PRODUCT YOURSELF

If you choose this option, you will be responsible for such things as:

- *Product design*
- *Manufacturing*
 - *Sourcing*
 - *Production*
- *Marketing*
 - *Scheduling and attending trade shows*
 - *Managing sales reps or entire sales effort*
 - *Developing and producing all promotion support (cost of brochures, ads, packaging, collateral support, catalog, etc.)*
- *Distribution and Inventory Management*
 - *Defining and selecting distribution channels*
 - *Packing*
 - *Shipping*
 - *Warehousing/inventory*
- *Customer Service*
 - *Handling returns*
- *Financials*
 - *Managing payables/invoicing*
 - *Collecting receivables/bad debt*
 - *Managing cash flow associated with inventory business*

In the greeting card business, Shapiro notes, you need five line changes a year. You have to deal with department stores, mass merchandisers and stationery stores. You have to attend dozens of trade shows. "Ultimately, they always tell me they really want to be a designer. They don't want to worry about invoicing and warehousing and accounts receivable and bad debts and all of that."

On the other hand, Shapiro says, she has seen many designers who have developed more complicated, three-dimensional products that require more sophisticated manufacturing and are unable to find a licensor. "They really believed in the product and were unable to find the right home for it. "As a result, she says, they decided to take the product to market themselves. "I've seen people take great joy in the whole process," reports Shapiro. "With some products, it's the only way."

OTHER MARKET ENTRY OPTIONS

There are other ways to get your product to market. You can simply sell your idea outright to an interested party for a flat fee. The down side is that you give up any and all future rights to your idea. This is considered to be work for hire.

A variation on this theme is to formalize an ongoing relationship with a manufacturer or an importer. You may transfer the design rights to another party, but you can still profit directly from the sales of the product through a royalty arrangement or indirectly through other forms of compensation such as company stock. Before you relinquish any rights and transfer the ownership of your design, calculate the potential lost revenue to make a more informed choice. For this formula, see "What You Can Expect to Earn" in chapter five.

In our case, the benefit of controlling every single aspect of the business was a necessity...but don't look at [product design] as a life plan...get some experience [with licensing] before you get in too deep.

—Karin Hibma
Cronan Artefact

On your own vs. licensing in the product development stage
Who's responsible for what and how much time is really involved? Here's a look at how two designers took similar products to market. Even in the development stage, the investment of time and the level of involvement required to manufacture a product is exponentially more demanding. This visual does not include postproduction responsibilities such as inventory control and management, shipping, receiving, etc.

	On your own		**Licensing**	
Product Name	Industria Clock		Staple Clock	
Designer	Peat Jariya		Constantin Boym	
Wholesale price of product	$60		$6	
Suggested retail price of product	$120		$12	
Other	Industria is one of ten designs. Some timeframes represent the time it took to develop the line.		Licensed to Elika	

Process	Hands-on involvement	How much time this step took	Hands-on involvement	How much time this step took
Product sketches	X	10 weeks	X (includes mock-ups)	4 weeks
Research	X	3 years	Not applicable	
Prototype phase	X	6 months	X	4 weeks
Final design/technical drawings	X	6 weeks	Not applicable	
Source materials and supplies	X	1 year		
Design package	X	13 weeks		
Develop pricing/distribution	X	1 year		
Get financing	X	self-funded		
Once designed, time to manufacture/ assemble first product	X	8 weeks		12 weeks
Prepare marketing materials	X	8 weeks	Not applicable	
Total development time		One year		About 6 months
# Units sold first year	500 each of 10 designs		3,300	
Total units sold	5,000		10,000 (approximate)	

HOW LICENSING CAN MAKE YOUR LIFE EASIER

"Licensing is a beautiful thing," emphasizes Jane Tilka, principal of Tilka Design. After having experienced both running her own retail business and licensing product designs, Tilka clearly prefers the latter. Early in her career, Tilka created and founded Sox Appeal, a sock retailer. At first it was fun and exciting. But after taking one too many trips to the East Coast to source socks while still operating a graphic design firm, she quickly tired of operating a product business and focused back on her career, graphic design. She located a franchise company to run Sox Appeal on a daily basis.

Over the last fifteen years, Tilka has licensed hundreds of product designs —among them: T-shirts, tiles and gifts—to companies like Rivertown Trading. She and her staff have designed hundreds of cards for Recycled Paper Products. And most recently, with Minnesota-based Metacom, Tilka and her staff have designed a clever line of CD-greeting cards which contain full-length CDs to fill market demand for cards that are also gifts in themselves.

Licensing, Tilka notes, provides what she calls passive income." You don't have to record your time. You don't have to do invoices," she explains." You don't have to hold inventory. You don't have to worry about whether or not your materials are going to show up on time." In fact, she says, "You don't have to do anything but design and maintain a good relationship with your partner company."

Does she worry about losing control? Tilka says she works closely with a number of product development specialists (someone who works for the licensee company and is responsible for finding suppliers and managing the manufacturing process). "We do have some control," says Tilka. "We look at prototypes, we go to press checks." As she sees it, right now licensing is the best situation for her in the area of product development. "Licensing lets you earn income while you sleep."

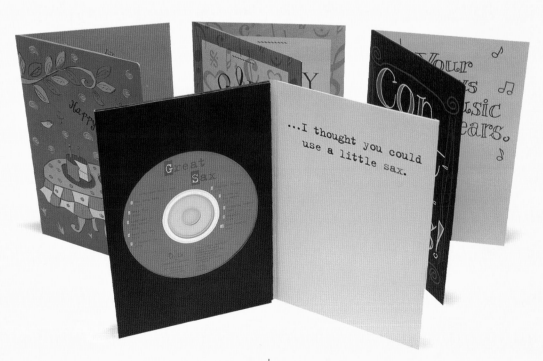

Adrienne Pollard says her husband and design partner, Jeff Pollard, used to turn to her and say, "Wouldn't it be great to design widgets?" Fatigued by creating brochures for such abstractions as financial services and insurance products, the Montana-based Pollards longed to create something tangible, "something people would actually need and use."

A friend introduced them to an importer who repackaged European products for the U.S. market. The company, Baudelaire, was cash poor. But they desperately needed a new identity and packaging to effectively position and introduce their line of naturally fragranced, triple-milled soaps imported from France. The Pollards agreed to take on the assignment in exchange for the opportunity to learn and for shares of stock in the company. Their design work met with a high degree of market acceptance.

Within five years, Baudelaire had increased its annual sales from $500,000 to $5 million, with the Provence Santé line representing 60 to 70% of the business. In the meantime, the Pollards gained experience and expertise. What started as a pure packaging assignment quickly evolved into legitimate product design. For one new product line, Essence, the Pollards designed bars of soap with inclusions from four natural origins (herbs, flowers, sea/water and earth/clay). For this work, in addition to a number of later line extensions, the Pollards were again compensated with Baudelaire stock.

In retrospect, the Pollards wonder if they placed a high enough value on their design services. If they had entered into a more traditional royalty arrangement (see chapter five, page 62) with compensation based on a percentage of net sales, they could have potentially earned $80,000-$100,000 from the first Baudelaire assignment alone. Did they pay too steep a price to get their experience? Both Adrienne and Jeff feel they made the right decision at the time. Their relationship with Baudelaire has continued to grow and their experience has enhanced their product design portfolio enabling them to take on new assignments that would not have previously been possible. In retrospect, Adrienne says if she could have done one thing differently, she might have

negotiated for additional royalties based upon sales. "Now we know," she says.

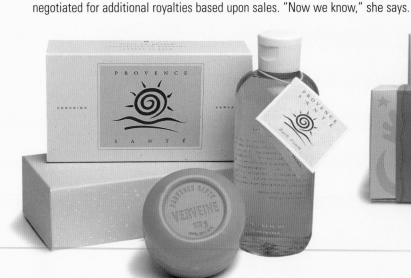

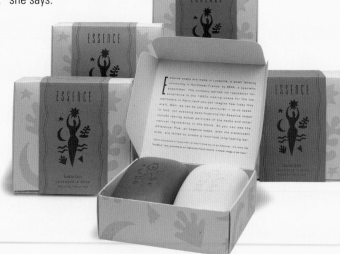

To determine the market entry option that is best for you, consider the following matrix. The options aren't mutually exclusive but the directions in which either will lead you are very different. The absence of an "X" doesn't mean you shouldn't consider that particular option; rather, the presence of an "X" generally indicates a higher probability that that option is more suited to you.

	Entry Option to consider			Entry Option to consider	
	On your own	Licensing		On your own	Licensing
What I'm looking for			**Work style**		
Ready for a major life change	X		Like to work completely independently		X
Want to try something new; not sure if product design is a life choice		X	Don't mind employing staff/ freelance resources	X	
			Like to manage people	X	
How I want to spend my time			Respond to change well	X	
Want to spend majority of my time designing		X	Want to be able to work on one thing at a time		X
Prepared to devote significant amount of time to nondesign endeavors	X		Like to start and stop projects when I feel like it		X
			Enjoy solving nondesign problems	X	
My Interests					
Prepared to start a whole new business	X		**Creativity**		
Enjoy "managing" nondesign things	X		Seek high degree of creative freedom	X	X
Have little desire to learn about or take responsibility for nondesign activities such as product costing, managing inventory and handling returns		X	**Level of Control Desired**		
			Desire total control over all aspects of design	X	X
Like to work on a variety of different projects at one time	X	X	Desire total control over all aspects of manufacturing and marketing	X	
Like to experiment with new processes	X	X	Managing every detail is important to me	X	
Like the business side of design	X				
Enjoy the mechanics and logistics of production	X		**Temperament**		
Like solving production-related problems in hands-on way	X		Don't like pressure		X
Don't mind travel	X		Good at juggling many things at once	X	
			Don't mind change	X	
Financial Resources and Needs			Easygoing	X	
Prepared to find money or invest my own money to develop my idea	X		**Skills and Expertise**		
Risk averse; prefer situations with relatively low degree of risk		X	Good planning skills	X	
			Ability to prioritize	X	
Don't need immediate income	X	X	Can see myself doing well in selling situations	X	
Willing to invest operating capital back into the business	X		Work well with a wide range of personalities	X	
Don't mind managing cash flow	X				

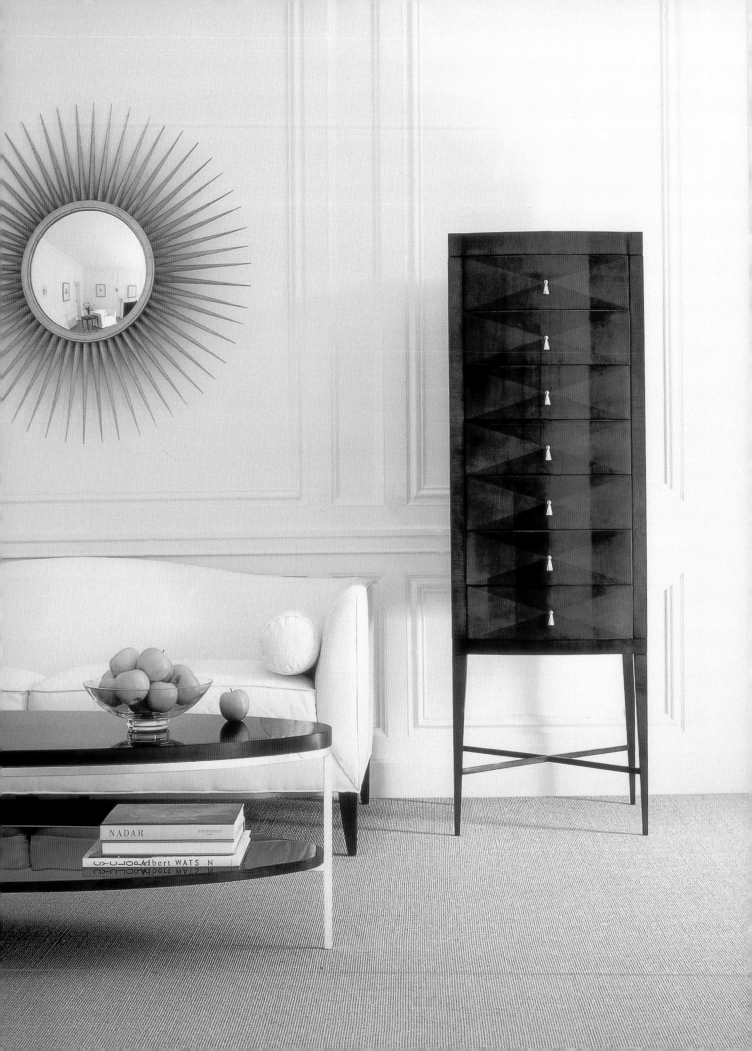

licensing

According to Martin Brochstein, editor of the *Licensing Letter,* the licensing industry has grown from $15 billion in North American retail sales in 1980 to $72.28 billion in 1996. This presents another viable way for you to introduce new products to market. Of particular interest to designers, illustrators and others in the graphic arts community is the rapid growth in art licensing. Art licensing includes artwork utilized for publishing purposes as well as licenses granted for merchandise such as apparel, home furnishings, giftware, stationery, tabletop items and housewares. This property category has increased approximately 20% per year since 1991 to a total of $5.2 billion in 1996.

Brochstein points to a couple of reasons for this growth. First, some manufacturers have cut back on their in-house design staffs to reduce fixed costs and to increase their versatility. Manufacturers are now using more outside resources. Second, it appears that more designers have either struck out on their own and/or have chosen not to sell their work outright because they want to maintain control over it. Lastly, licensing has become a more accepted practice among artists and designers. Brochstein says he thinks that the stigma of "selling out" by "placing fine art on a mug" does not exist to the same degree it once did.

Licensing is a good way to enter the field of product design without making a lifetime commitment. As a licensor, you are responsible for researching, developing, creating and protecting the idea for your product. The licensee is responsible for manufacturing, marketing and selling the licensed product.

THE RISKS AND REWARDS

Licensing enables you to focus on what you do best—designing. If that's your primary interest, then the rewards of licensing will probably outweigh the risks.

The biggest gamble you'll take as a licensor is the possibility of the loss of control over your work. How your product will be manufactured, marketed and sold—and how your product is presented to the marketplace—are controlled by the licensee.

Nevertheless, as a graphic designer, you are in a very unique position. You can bring added value to a licensee and exercise control over the way your product is presented to the market if you negotiate for involvement in such areas as packaging, displays and sales support materials.

FINDING THE RIGHT LICENSEE

The most logical place to start in finding licensee prospects is to align yourself with a manufacturer in the industry in which you want to license your product. Where do you start to identify contacts?

- Look to your own client base for opportunities. New York-based Designframe created a perpetual paper calendar and licensed it to one of their clients. Michael Vanderbyl's graphic design and merchandising work for leading furniture contractors gave him the opportunity to move into three-dimensional work.

- Look for contacts where the sale will be made. If you have a design for a clock you believe will be successful in a high-end gift shop, museum store or boutique, visit those retail outlets. Identify companies which are already successfully distributing similar or like products in those same venues. And don't be shy—if the name of the manufacturer is not readily apparent on the product, turn it upside down and write down the information you need! Or tell the

LICENSING BASICS

A **property** can be a name, a graphic, a logo, a likeness, a saying, signature or a combination of any/all.

You are the **licensor**, the owner of the property.

The renter, or the party to whom you grant rights, is the **licensee**.

Rights to a particular property are granted for a specific purpose, for a specific period of time in a defined geographic area.

In return, the licensor is paid a **royalty**. This is generally a percentage of the wholesale or net sale price of every product sold.

Licensing agreements are directly tied to product sales. The royalty percentages vary by industry with the most common percentages averaging 5–10%.

A **guarantee** is a minimum royalty payment that the licensee agrees to pay the licensor, no matter what happens to the sales of the product. The purpose is to underline the licensee's commitment to sell the property, and to assure the licensee has the incentive to do so. Actual royalty payments accrue against the guarantee amount.

The money that is paid up front to the licensor, which is part of the payment required for a license, is called an **advance**. It is often a portion of the guarantee.

store manager what you hope to do. Often they will be more than willing to provide you with names. You can also find the names of manufacturers, contractors and suppliers in the *Thomas Register* (for more information see chapter six and chapter twelve).

- Attend industry trade shows. You will quickly be able to identify potential suitors to determine if your product will complement their existing product line, and have an opportunity to meet key executives.

- Get a licensing agent. Some industries, like the toy industry, utilize agents. Without one, it may be impossible for you to get access to a decision maker. Licensing agents receive payment in the form of commissions so it's better, if you can, to deal directly with a company. If this isn't possible, look for a *Who Makes It* directory published by Standard Rate and Data in your library. Also, someone who can act as a "licensing agent" for you may have nothing to do with the licensing industry. Anyone who can give you an introduction to a decision maker is a potential contact. Ask friends, family and acquaintances who they know. Someone may be even more motivated to set up a meeting for you if you offer a modest fee.

- Finally, some graphic designers, like Detroit's Dominic Pangborn, principal of Pangborn Design, Ltd., utilize licensing shows such as the International Licensing Show, held annually, to display their wares (for more information, see "Licensing" in chapter twelve).

PREPARING FOR A PRESENTATION

Once you've narrowed the list of contacts, it's time to present your idea. Many companies already have procedures in place to systematically review new product or design submissions; some even provide specific guidelines for what types of products they are interested in. Before sending in any unsolicited ideas, call the company to determine what process you should follow.

Next, learn about the company and their business before you meet with them. Make sure that your product appears to fit within their present lineup. If they have a catalog, get a copy of it. If they have a Web site, visit it. Find out what they want and the kind of things they're looking for or you will simply waste your time.

Every situation is different but your next goal should be to get a face-to-face meeting with the potential licensee. The better your presentation, the better chance to generate interest in your product.

PROTECT YOURSELF

Before you submit your product idea to anyone, be sure to give it the legal protection you can. This makes you a more valuable prospect to a licensee. Patent it, trademark it, or copyright it (for specific information on registering or obtaining these, see page 136).

Copyright

Current copyright law automatically protects your artwork or design from the moment it's created whether or not it is accompanied by a copyright notice. Notification of copyright, such as in the use of ©, accompanied by the name of the creator or representative company, and the year of creation will strengthen any subsequent claims, e.g. © Jim Coon, 1998 or © DiBacco Design, 1999. A good habit to get into is to "circle-C" and date everything you do.

The best thing about licensing is to receive a substantial royalty check in the mail for a product you designed ten years ago (and already barely remember).

— Constantin Boym
Boym Design Studio

WHAT TO INCLUDE IN YOUR LICENSING PRESENTATION

- *Why there's a need for this product or "property"*
- *Why it's an improvement over what's already in the marketplace.*
- *Prototype, mock-up or drawing. (If it's not feasible to transport your product or you fear it will be damaged, take a photograph of your prototype against a white background.)*
- *Who you think will buy the product. (Substantiate with any research you've conducted such as interest from retailers.)*
- *What the product might sell for (see chapter seven).*
- *Evidence that the costs of the product are in line with the profit potential (see chapter six and chapter seven).*
- *Why you think this product is right for the licensee.*

SUCCESS WITH LICENSING

The who is Dominic Pangborn and the what is a $3-million-dollar-a-year product design business. His colorful designs have been compared to the likes of the late Gianni Versace and his cool-headed marketing savvy have left others wondering if he's the next Ralph Lauren.

Several years ago, the textile manager of Daewoo Corporation, the giant South Korean conglomerate (a graphic design client of Pangborn Design, Ltd.), asked him whether he'd ever thought of applying his designs to ties. That night the prolific Pangborn went home and created twenty-five tie designs. The next day he showed them to the division manager. He thought they were nice—in fact too nice for their customer, Kmart. Pangborn was then referred to a small tie manufacturer in Korea.

His first ties appeared at Saks Fifth Avenue in Dearborn, Michigan. More than two hundred ties sold out in one month. Within a short period of time, Pangborn parlayed his success to dozens of other retailers including Saks' flagship store in New York. In 1995 he designed a line of women's scarves. An initial collection of thirty-six thousand scarves in twelve designs sold out. From there, Pangborn has expanded his offering to include note cards, desk accessories, even fine china. Many of his product designs are based on the look of his ties, designs Pangborn creates when he travels on airplanes. These days, he travels a lot.

Pangborn Design markets its products under several brands: Pangborn Design Collection, Pangborn Museum, Pangborn Home Collection, as well as under private labels. He actively seeks customers who want to license the Pangborn Design brand or want to incorporate Pangborn products under a private label. To date, he has six licensing agreements, one with Gerber Products Company. The domestic response to Gerber's collector series of baby bottles was so strong it has been launched internationally.

How does Pangborn Design find licensees? "Trade shows and personal contact," says the company's merchandising vice president, Karen Parente. "The International Licensing Show helps us to meet the right people," she says. Though Pangborn had worked with Gerber through his graphic design practice, the firm's contacts were with marketing and communication types. At the show they ran into the product people. "This gave us credibility in a whole new light," notes Parente.

Registered copyright

It's also wise to formally register your work with the Copyright Office. This establishes a public record. If someone infringes or copies your creation without your permission, the burden to prove otherwise is then shifted to the other party.

Patent

A utility patent applies to the creation of a basic new process, machine or manufacture. The other type of patent, a design patent, is more likely what you'll be interested in obtaining. A design patent offers protection for a unique design of the exterior of a product. It has to do with how the product looks but not how the product works. When something says "patent-pending" it could refer to either type of patent.

Trademark

You can also protect your product idea with a unique name or look. The ™ symbol can be used by anyone. Its use on a product indicates that you believe the product or the design is not to be infringed upon. Some of the products featured in this book which are trademarked include Applied Chemistry™ and Expressionizm™. The use of the ™ symbol doesn't signify that it has been registered, however.

To register, you must apply with the Patent and Trademark Office (PTO). Trademarking can become complex. For maximum protection you must register for each product class in which you might use it and for each geographic region in which you sell it.

Consult your attorney for more information.

WHAT TO INCLUDE IN YOUR LICENSING AGREEMENT

No matter what, you should consult an attorney before drafting or entering into a licensing agreement. The licensing contract will normally include the following elements.

Description of the property

Include an explicit description of what is to be licensed.

RIGHTS

Product manufacture

Specify who will manufacture the product. Consider if you desire the right to pre-approve the use of any subcontractors the licensee may hire to manufacture your product. Specify materials/design to be used in manufacture.

Note the key stages during production in which you are to have approval to ensure quality of materials, colors, fabrication, etc.

Distribution

Specify who will sell the product. Specify the distribution channels which are to be utilized. This will help you control where your product is to be sold. It will prevent the licensee from selling your product in certain venues without your permission.

Geography

Specify the geographic areas where sales are permitted.

Promotional Support

Reserve the right to review and approve all promotional materials created in conjunction with the promotion of your product, in advance of their release.

Specify how the likeness of your product may/may not be used by the licensee.

Identify the level of promotional support that is expected by both parties.

If desired, negotiate separately for the right to create and oversee production of all materials (such as packaging, advertisements, sell sheets, merchandising, displays, collateral, etc.) that are to be produced in conjunction with your product.

(Continued on page 61.)

Michael Vanderbyl always wanted to be an architect. But a high school counselor told him he wasn't smart enough "because my math skills were lacking," he says. Instead, Vanderbyl became a graphic designer.

Early in his career, Vanderbyl did a great deal of work for contract and office furniture companies like Hickory Business Furniture (HBF). He frequently found himself on product review committees. Responsible for the image of the companies, their graphics, showroom designs, cataloging and merchandising, Vanderbyl was thought to have a good grasp for what customers expected from their firms, so clients consulted with him on what to include in their lines. Years ago, in a product review with client HBF, twenty to thirty different designs were under review. The client chided Vanderbyl, "You hate everything. Why don't you try to design something?" He jumped at the chance. The result was a chair which received accolades from the former Institute of Business Designers (IBD). "Truthfully, it was a really uncomfortable chair," says Vanderbyl, "but boy, did it look cool."

Sheets, fabrics, lighting and furniture are a few of the products Vanderbyl has successfully designed under royalty arrangements with apparel and home furnishings companies like Esprit and furniture manufacturers Boyd and Baker. Vanderbyl says he earns 3% on net sales for his work in the furniture industry and adds that no design fees are paid by the manufacturer up front "unless there's a new technology involved."

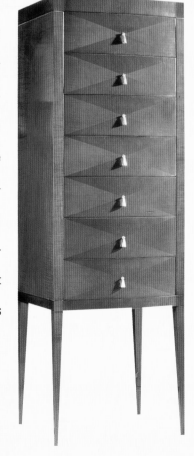

Vanderbyl is proof that leasing rights to clients doesn't necessarily mean a loss of control. In some situations he is able to control the presentation of his product designs by managing various promotional, collateral and advertising materials through his design practice. In advertisements for Boyd, Vanderbyl is credited as the furniture designer. Media placements in national, high-circulation home decor and interior design publications have helped Vanderbyl establish a name for himself among the trade and among design-oriented consumers.

At fifty, Vanderbyl has already earned a lifetime achievement award from the prestigious Pacific Design Center. Today, he is considered one of the country's leading product designers (and the irony of it all is that much of his work is architectural). For that, he thanks his high school counselor.

**Average Royalty and Range of Royalties
(By Product Category, 1996)**

Every industry is different and the ranges of compensation vary hugely as evidenced by the following. Use these royalty rates as a guide but don't use them as a bible. Royalty rates can easily fall above or below the reported ranges.

Product Category	Average Royalty (96)	Average Royalty (95)	Range
Accessories	8.6%	7.7%	5-12%
Apparel	8.6%	8.6%	5-12%
Domestics	7.5%	7.4%	4-10%
Electronics	9.0%	6.5%	4-12%
Food/Beverages	8.7%	5.8%	3-15%
Footwear	6.2%	8.0%	3.5-12%
Furniture/Home Furnishings	7.3%	7.8%	5-14%
Gifts/Novelties	10.0%	8.6%	5-15%
Health/Beauty	N/A	9.0%	N/A
Housewares	8.0%	8.5%	5-10%
Infant Products	8.4%	9.4%	6-11%
Music/Video	11.6%	11.0%	6-15%
Publishing	10.2%	9.0%	6-15%
Sporting Goods	8.0%	8.0%	7-10%
Stationery/Paper	8.6%	8.0%	5-12%
Toys/Games	9.8%	8.6%	5-15%
Videogames/Software	7.5%	7.7%	4-12%
Overall Average	8.9%	8.3%	3-15%

Note: These are average royalties by product category as reported by respondents to the *Licensing Letter's* Annual Licensing Business Survey; thus, royalties for individual deals may fall outside these ranges. N/A indicates there were not enough responses for a meaningful number.

Source: *The Licensing Letter.* © 1997 EPM Communications, Inc.

WHAT ABOUT NONDISCLOSURES?

Well-meaning friends and others may suggest that before you reveal your idea to anyone, you prepare a nondisclosure form, or confidentiality agreement, and ask a representative of the licensee to sign it. Although this should not be construed as legal advice, you are already protected if you have trademarked or copyrighted your idea (see "Protect Yourself," page 56). Plus, the truth is that company employees are usually not allowed to sign contracts on behalf of their

WHAT TO INCLUDE IN YOUR
LICENSING AGREEMENT

(continued from page 58.)

COMPENSATION

Royalty rate

Specify the percent you'll earn on net sales. Specify how net sales are to be defined. Note any agreed-upon deductions that you consider to be allowable against net sales (standard deductions typically include cost of shipping, returns and discounts).

Guaranteed Royalty

Specify the required minimum guaranteed royalty, called the "guarantee," that the licensee will pay during the contract period, whether or not the licensee has sold your product.

Advance payments

Determine the amount of your advance and when it is due to you (usually due upon signing of the contract).

Payment schedule

Specify the method of royalty reporting. Keep in mind that the more detailed information you are able to get, such as sales by region or sales by account, the more you'll learn for the future. Include a penalty for late payments.

NOTICES OF PROTECTION

Copyrights, trademarks, etc., should be identified on the product and your contract should specify so. This is also in the best interests of the licensee and they will want to do so.

INDEMNIFICATION

Make sure that your licensing agreement includes product liability insurance that jointly names you and the licensee against claims, suits, etc., arising out of any alleged defects in the product.

company without involving the firm's legal counsel, so your request for a nondisclosure agreement can slow things down or even halt the process altogether.

The company you're contacting may already have guidelines in place regarding product submission procedures which may include conditions under which they will accept submissions. Conversely, they may ask *you* to sign a waiver that indicates that you understand how the company handles idea submissions and the extent to which you are protected. It's up to you. If you have already protected your idea to the extent possible and want to license your product, you'll need to sign their nondisclosure agreement, if they require it, in order to move forward. In either case, consult an attorney to help make the right decision for you. (You can download a sample confidentiality agreement from www.core77.com but the creators make no claims to its legal potency. For more information, see "Product Design" in chapter twelve.)

CHOOSING THE RIGHT LICENSEE

You can minimize the risks of licensing by selecting the right licensee at the outset. Closely discern the licensee's:

Product line

Does your product complement the licensee's existing line? Does it fit?

Product quality

Is the design and quality of the finished goods the licensee has produced consistent with the way you want your product to be represented in the market?

Track record

How successful has the licensee been with licensed products? What sales results were achieved? Over what period of time? Ask the

licensee directly for this information. Or, ask them for the names of other licensors they've worked with. Call them and find out about their experience.

Product manufacture

Will your product be manufactured in house or subcontracted? If it will be subcontracted-out, how will quality be monitored and maintained?

Distribution

One of the primary reasons you will select a particular licensee is for its ability to guarantee distribution through a particular channel. What relationships does the licensee have?

Sales

How will your product be sold? What does the licensee forecast for your product? Does this meet with your expectations? Is it consistent with similar products in the category?

Marketing

How will the licensee promote your product?

WHAT YOU CAN EXPECT TO EARN

Your income will generally be based upon a percentage of the wholesale price or the net sale price of your product. Royalty percentages often range between 5 and 10%. You can guestimate what you might earn using the following sample calculations.

Scenario 1

You design a toy that retails for $50. Your licensee sells 20,000 toys at a wholesale price of $25.00 (wholesale price is generally half the cost of the retail price). You have negotiated for a royalty of 5%. In this scenario, the payment to you is:

20,000 units x $25 x .05 = $25,000

Scenario 2

You design a chair and licensee offers you "3% of net" (meaning 3% of net sales or, the wholesale price of the item minus allowable deductions). The net price of the chair is $245. The licensee projects sales of 1,500 chairs. You can expect to earn:

1,500 units x $245 x .03 = $11,025

Scenario 3

You hook up with an apparel manufacturer who licenses the rights to market four of your T-shirt designs. The licensee sells a total of 500,000 T-shirts at a wholesale price of $7.50, paying a royalty of 5%. The payment is:

500,000 units x $7.50 x .05 = $187,500

The three scenarios described above are the same in that the royalty calculations are based on net sales. There are other formulas for royalty calculations such as those on cost or retail price. For more information, read The Licensing Business Handbook *(see "Licensing" in chapter twelve).*

FOR SAGMEISTER, IT'S NOT ABOUT MONEY

Lots of interesting product ideas never see the light of day. That's what Stefan Sagmeister learned from his first attempt to license a product design.

Sagmeister engineered a cardboard postcard mailer which, with a few folds here and there, transforms into a tabletop sundial. When the sun shines on the dimensional dial, the shadow reveals the time of day. The angle of the dial adjusts to work in most major American cities. From Atlanta to Anchorage, the Sundial Postcard is guaranteed to be plus or minus only five minutes per day.

Believing the timekeeping device to be appealing to a design-sensitive clientele, he took the idea to the Museum of Modern Art (MoMA) in New York. The idea was rejected, says Sagmeister, because "it was just too difficult for them to produce and too costly for the estimated return based on the quantity they'd need." He adds, "A card can't sell for much more than $2. That means you have be able to produce it for $.50 including your own design costs." Sagmeister considered producing the card himself but it didn't make sense. He'd have to run 10,000 units to get his costs in line. Even if he could get his outside costs down to $.30 per card, he'd make $.20 per card, or $2,000 on 10,000 cards— "not a lot," he adds.

Though the Sundial Postcard wasn't commissioned by the museum, MoMA was impressed with Sagmeister's work. He was asked to design a holiday card for which he is paid a royalty based on performance. It was subsequently produced by the museum and sold through The MoMA Design Store and through MoMA's catalog operation. The museum, which also operates as a wholesaler, also sold the card to retail outlets at gift and stationery trade shows. The initial run was 10,000 units. Sagmeister reports that he's earning a percentage on net sales. "It's not a lot," he says, "but having a holiday card from MoMA is a really sweet thing for a designer." He adds, "it's not something I'd do to keep the studio alive."

The Sundial Postcard was ultimately produced. It became a self-promotion for Sagmeister Inc. Mailed to clients, prospects and friends it served as a reminder to "have a sunny day."

CHAPTER 6

Finding quality materials and suppliers to aid in the manufacture and assembly of your product is the next step in the product design process. If you've chosen to license your idea, the process of sourcing materials is invaluable even if you never ultimately purchase the materials yourself. You may wonder, "Why bother? Let the licensee figure it out!" But the process will make you a more informed licensor and will give prospect licensees the confidence that, (1) you've done your homework, and (2) you know what you're doing. If you've chosen to manufacture and market your product yourself, the suppliers you choose can mean the difference between success and failure.

The process of sourcing will give you a good grasp of:

(1) *Variable costs of manufacturing your product.* This will help you later on as you develop a pricing strategy.

(2) *Material limitations.* What can and can't be done.

(3) *Assembly considerations.* How the product will be assembled in real time and identification of all the steps that will be required to take your product from concept to completion.

(4) *Industry terminology.* What you think you're asking for may not be what the supplier thinks you're saying. Learning to "talk the talk" will give you more credibility.

(5) *Which suppliers will perform.* You will quickly find out who you can rely upon to make your vision a reality.

WHERE TO START

Assuming that what you're creating is new and different, there probably isn't one single place you can instantly turn to find exactly what you need. Think of sourcing as a scavenger hunt. Be patient and

persistent. Some contacts you initiate may run into dead ends, others will serve as clues that will ultimately lead you to find suppliers that meet your needs and requirements. There is no magic secret to finding sources of supply and you may find them in the most unusual places. There are two things to remember: persistence pays and no question is a dumb question. Here are some of the best places to get started:

www.thomasregister.com

You can conduct an on-line search of manufacturers of materials and products within specific industries. This is the on-line version of *Thomas Register of American Manufacturers,* which is one of the most comprehensive resources you can draw upon. As such, it's a good place to start. Or, if you prefer, there are three sets of published volumes: 1-22 list products and services alphabetically by category; 23 and 24 list company profiles; and 25-33 include actual catalog information. The books are available in most libraries.

Industry buyer's guides

Most leading trade publications publish some type of annual buyer's guide. To find the leading trade publications, ask.

The Yellow Pages

Get out the old phone book. Sounds basic but a few calls to local firms may help point you in the right direction. Example: If you're looking for a company who can make custom metal boxes, call metal fabricators and ask them if they can do it, or if they can refer you to someone who can. If they don't know anyone, ask them if they know someone who might know. One referral will lead to another until, finally, you'll find the right source for you.

help

Trade shows and conventions

Attending leading industry trade shows is an excellent way to find out what's going on in the industry as well as a good place to find resources to work with. There are also hundreds of regional/local industry shows that might prove helpful; as you make contacts with manufacturers, ask which shows those suppliers attend (for more information, see "Trade Shows" in chapter twelve).

Trade organizations

Call the leading trade organization in the industry and ask for a list of members. Also ask for copies of promotional materials or registration information from recent seminars, conferences, etc. sponsored by the organization. Often those materials will include names of experts.

Connect the dots

How do you find someone to sew the spine of a blank journal? Think about what kinds of places might do industrial-type sewing. Upholsterers, tailors, costume makers and even sail makers are worthwhile places to start looking. If the first few you contact are unwilling to tackle your project, don't lose hope. Chances are one of the people you contact will know someone who can help.

Specialty outlets

Hardware stores, hobby stores, craft supply stores, floral shops and other similar retailers are all good places to source unusual materials and objects.

Catalogs

Specialty catalogs and wholesale catalogs are useful. They often can be ordered directly from manufacturers. They may even serve as inspiration for new product ideas."What can I make with that?" As you contact companies, start a resource library filed by subject.

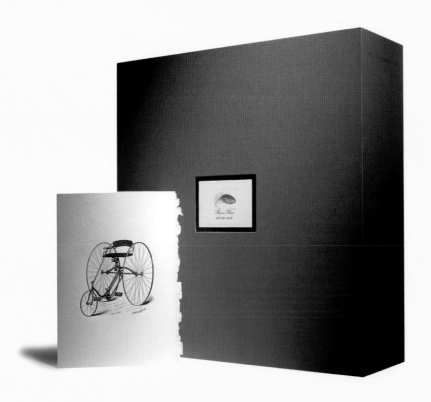

OBSESSED WITH QUALITY

ENCRE, the French word for ink, is the name of the custom card and invitation company started by Connecticut artist and former caterer René Hue. In her collection you'll find antiquarian images, original artwork, luscious hand-lettering, richly detailed engravings and embossings, imported papers with fancy deckles, handmade ribbons and found objects. Now these are the kind of cards you send when you really care enough to send the very best (one of their top clients is Neiman-Marcus).

Hue had a self-imposed deadline. In order to get her products out in time for the 1996 Christmas holiday season, she had to be at the National Stationery Show in May. What she had was a vision. What she didn't have was a product line.

First, she needed a calligrapher. Hue recalled her own wedding invitation and called Sandra McDonnell of SJM Design, Darien, Connecticut, who used to be the full-time calligrapher for Tiffany's. (Her work has also been used by Cartier as well as on Oscar invitations.) McDonnell supported the initiative. One down, four to go.

Artwork. Hue sought the unusual. She started attending ephemera shows. "I didn't even know what they were until I went to one, but now I search all the ephemera shows, bookstores and antiquarian stores for images that we might use in the line." Old prints, elaborate etchings, bookplates, invoices, posters—if it has reproducible art that fits an ENCRE theme, Hue acquires it. (To date, she estimates that she has seven to eight hundred images and admits that the search is "ongoing" and "endless.") Two down, three to go.

Paper. Hue demanded only the finest. She had collected paper samples for years, meticulously tucking away swatches and recording the ones that she liked best. Talas, in New York, became one of her best sources for the unusual. With their help, she lucked into an importer of exquisite papers handmade in Germany and Czechoslovakia with four-sided deckles. "Outrageously expensive," admits Hue, "and perfect for the line." Three down.

Ribbons. Personal experience counts. The graduate of the Fashion Institute of Technology (FIT) laughs, "I used to be in fashion design so that part was easy." What next?

With just twelve weeks left before the show, Hue had to do the seemingly impossible: produce the entire custom line. That meant twenty-five collections, with five or six pieces per collection (invitation, envelopes, reply cards, etc.). Set all the type. Engrave all the images. Place them in a custom portfolio (which also had to be designed, embossed, produced, collated and hand-assembled). McDonnell referred Hue to one of the country's leading engraving firms, Continental-Anchor Ltd. of Long Island City, New York. For three weeks straight, Hue and Continental's management held day-long production meetings. After four weeks, Hue had proofs. And within days before the show, Hue had a complete line. The reaction from the trade? "What silk is to a pillowcase, ENCRE is to the invitation," said one attendee. How does she do it? "By finding others like me who are obsessed with quality," says Hue.

Bookstores and libraries

Subject books, written about the materials you're using, such as those on woodworking, glass, etc., will often list suppliers in the book's appendix or index. They can also be useful in helping you to understand specifics of the materials you plan to work with. For instance, if you're working with wood, you'll want to understand the differences between hard woods and soft woods as well as the impact of your specification relative to grain, ease of cutting, sanding, denting, splintering, aging and shrinkage. If you're working with acrylics, you'll want to find out the differences between cell cast acrylics vs. melt-calendar acrylics and the impact of your choice on product cost. If your product utilizes adhesives, you need to know about different adhesives for porous versus nonporous materials. Look for industrial guides to specific materials such as *Walden's ABC Guide*.

Publications in related fields

Do architects, interior designers or other professionals in related fields use the materials you plan to manufacture with? If so, the trade publications they read can be helpful. Again, check out buyer guides. And read the display as well as the classified ads; sometimes they can be helpful.

Artists

Local artists, art cooperatives and craft schools are often good sources of material-specific information. Many co-ops and schools have fully equipped studios and offer short, intensive courses in glass, metalworking and wood studies. You might attend a class or simply request a catalog. Or track down one of the instructors.

On-line

Roaming around on the Web can provide you with dozens of resources. For example, a site called the Apparel Manufacturer's

The ancients perceived—in very specific terms—the inherent personalities of all material things. Stories relating qualities to materials, such as the aggressiveness of Mars (iron), the melancholy of Saturn (lead), or the tinged beauty of Venus (copper), are expressed throughout their myths. Even within the radically different context of our world we may still listen to the voice of materials in order to choose carefully those that will speak for us.

—Daniel E. Kelm, Foliotrope

Sourcing Web offers sources in seven major categories including construction materials, fabrics, trimmings, fasteners, obscure materials, etc. To access: www.halper.com/sourcingweb

Ask, ask, ask

The best sources of supply will be found with persistence and dogged determination. Don't be afraid to ask anyone you know for a referral.

SHOULD YOU BUY WHOLESALE OR RETAIL?

wholesale

or

retail

The question of whether to buy wholesale or retail will probably be dictated by the volume of your purchase. If you are purchasing enough raw material to fabricate prototypes, you'll probably purchase a small quantity of material from retail outlets. But, if you're ready for a full production run and can meet the manufacturer's minimums, opt for wholesale. It's less costly.

HOW CAN YOU BE SURE YOU GET WHAT YOU ORDER?

Working with a new supplier can be a harrying experience. To minimize frustration and to ease possible communication mishaps, be sure you communicate clearly what you're looking for and when you need it. Along with your order for a specific piece or component, e.g.,"10,000 Chicago Screws, plastic injection molded to match PMS 842," you might send a blueprint of your product design to each supplier who will be involved in the product. This will enable them to see how their materials will be used. Not only will this give them something concrete to work with, it will permit them to see how their contribution affects the whole. As such, they may be more inclined to double-check measurements, etc.

Daniel Kelm is an experimenter, an inventor and an accomplished book artist. He has taught at a prestigious list of schools, among them Brown University (Providence), the Center for Book Arts (New York) and Art Center of Design (Pasadena). In his teachings, he focuses on the narrative qualities inherent in material, structure, surface and enclosure. Kelm is also the founder and director of the Garage Annex School for Book Arts in Easthampton, Massachusetts. The school offers opportunities for instruction at all levels to bookbinders and artists. With a degree in philosophy, plus major work in chemistry and education (he taught chemistry for a time), Kelm's long-time interest in finding out how and why things work has helped him to shape an understanding and respect for materials.

He and partner Greta Sibley have created a line of personalized portfolios called Foliotrope. Available in standard or custom sizes, Foliotrope gives designers, artists, architects and photographers presentations that enable the owner to rearrange the contents whenever they wish. What each presentation has in common is its binding. Invented by Kelm, the books are bound with a patent-pending, microhinge spine structure. Crafted from intricate metal pieces, the spine enhances material integrity and creates the illusion of permanence.

But unlike books with more mundane wire or plastic bindings, a Foliotrope presentation can be dismantled and reassembled with a simple tool that comes with it. Artist images might be etched into a cover made from a sheet of metal. Covers might also be fabricated from sandblasted copper or aluminum, or crafted from embossed leather or Ultrasuede—just to name a few other choices. Kelm imposes few limitations on what's possible. As such, each Foliotrope is a unique statement and reflection of its owner. "Supporting ideas with unusual materials makes them compelling in a way that disembodied pieces can never be," he says.

Due to the highly individualized approach Kelm takes to designing each job, sourcing is critical to his success. In addition to using the sources listed earlier in this chapter, Kelm maintains a library of Yellow Pages from larger cities like New York, Chicago and Los Angeles. You can purchase these yourself; call your phone company. He frequents industrial libraries, which most universities have. Once Kelm has identified a company that produces materials related or similar to what he desires, he often calls to ask for technical assistance. "This is a good chance to talk shop. The technical people want to help, not sell, and this is very helpful when I want to understand material strengths and limitations." Finally, Kelm says he asks for catalogs and samples at every place he calls, noting "you may love what they send you for another project."

Once you've identified potential resources, you need to find out who will work best with you to help you achieve your goals. Some designers let quality drive vendor selection, even if the price is a little high. Use this checklist for guidance.

Overall responsiveness How responsive is the supplier early in the selection and review process? Are they helpful and willing to answer questions?

Capability Does the supplier have all of the resources required in-house to produce your job? Will any special materials need to be sourced by the manufacturer?

Development Is the supplier willing to work with you to develop a prototype? What are the associated costs? Do they include revisions and alterations? How far is the supplier willing to go to help you achieve your goals?

Quality Is the quality of the finished goods they have produced for others consistent with the expectations you have for your product? How is quality controlled?

Consistency of manufacture How will consistency from run to run be addressed? Will they assure color matches?

Responsibility Will the manufacturer work with any subcontractors? How will your supplier monitor their quality and performance? Who within the organization will be responsible for monitoring and ensuring your delivery? Will it always be the same person?

Price What are the costs of the finished goods from door to door? Will the manufacturer incur any up-front expenses in the fabrication of a piece, part or whole product? What is the minimum first-time order you can place? What is the minimum required for a fill-in order? Do any volume discounts apply?

suppliers

Ownership If a supplier works with you to develop something you would consider to be unique to your product, what assurances are they willing to provide that they won't sell it to someone else?

Terms Is the manufacturer willing to extend payment terms that are agreeable to you?

Domestic/overseas Will the materials be sourced domestically or overseas? How will this affect availability and timing?

Location Is it important that the supplier or manufacturer be located in close proximity to your business for quality audits, etc.?

Environmental considerations What materials, chemicals and substrates are used in the manufacturing process? Are they harmful to the environment? How is waste disposed of?

Employee base Are the employees part-time? Full-time? Free-lance? Skilled? Unskilled?

Turnaround What is the turnaround time for an initial order? What is the turnaround time for future orders?

Flexibility of supplier How willing is the supplier to work with your terms (deliveries, small minimums, changes/alterations)?

Attention to detail What system is in place to ensure that materials are assembled the way you've specified?

On-site resources Does the supplier have the resources needed on-site? How will they be obtained? Will quality be ensured?

Willingness to work with you Will the supplier take an active role in ensuring your success? Does the supplier understand what you're trying to do?

Working environment Is the environment clean? Does it appear to be safe?

Reputation What do other customers think of the supplier? Ask for the names of references and call them.

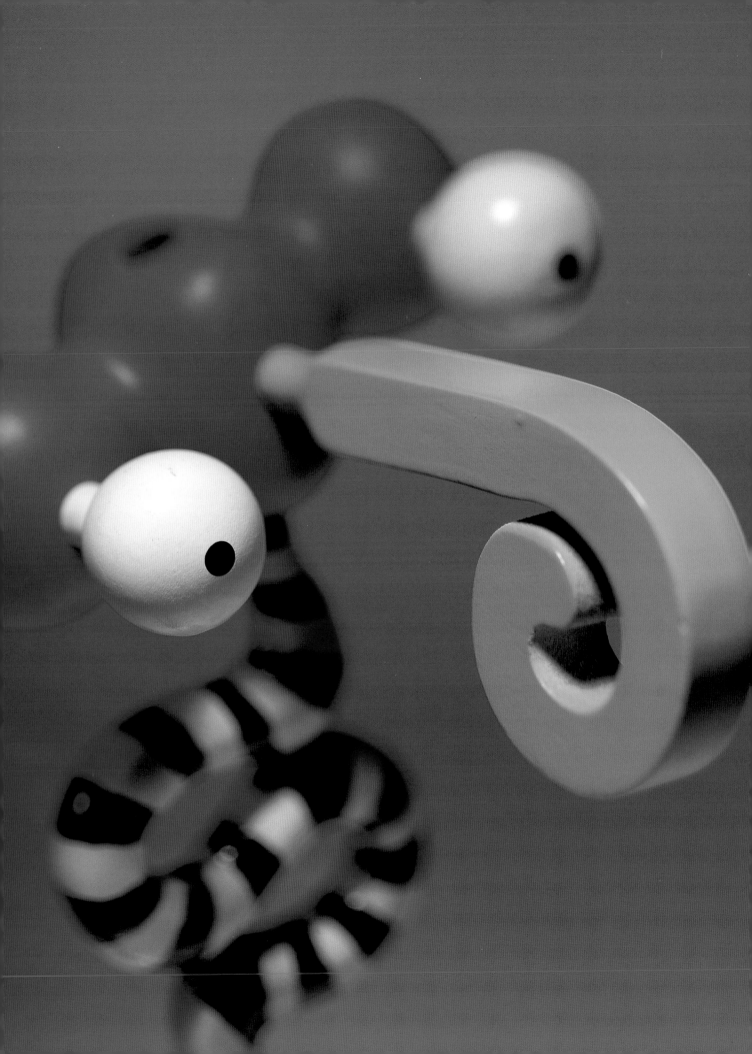

CHAPTER 7

pricing

This chapter is intended to help price your product and decide where to sell it. Specifically, it will help you to:

(1) Determine the cost of your product.

(2) Develop a pricing strategy.

and

(3) Understand how pricing works in the retail world.

(4) Run a break-even analysis.

(5) Determine the quantity of your production run.

distribution

(6) Run a Profit and Loss Statement (P&L).

(7) Select the right channels of distribution for you.

Determining a price for your product should be simple in the sense that the best price is a combination of what the consumer is willing to pay (demand) and one that gives you, as well as others in the distribution chain, a fair profit.

FIGURING OUT YOUR COSTS

The first thing you should do to determine the price of your product is to figure out the cost of producing your product. There are different kinds of costs: fixed costs and variable costs. Your fixed costs are the expenses you incur no matter how many products you produce.

Fixed costs typically include salaries, taxes, equipment, rent, utilities, etc. These costs are the same whether or not you produce one unit or one zillion units. However, your fixed costs per unit will decrease as you increase the quantity you produce. Example: If your fixed costs are $10,000 and you produce one unit, the fixed cost per unit (CPU) is $10,000. If you produce 10,000 units, the fixed cost per unit drops to $1.

Variable costs include the direct costs to produce your product. Your variable costs may fluctuate based on the quantity you produce.

Variable costs typically include: raw materials for your product, conversion expenses, assembly costs, labor/subcontracted services, cost of sales (i.e., sales commissions and fees), cost of returns, packaging costs, freight and marketing expenses.

DEVELOPING YOUR PRICING STRATEGY

Once you've been designing and manufacturing products for a while, you'll have a better idea of how your industry works and the market conditions that will help you set the best price for your product. An accountant, or someone who does work in similar industries, can be an invaluable resource. But your accountant shouldn't be expected to set your price. Utilize your accountant to help you make sure you've thought through everything you need to. Assuming that you're designing a niche product (versus a mass market product), the best way to start thinking about price is by using a cost-plus pricing strategy.

In this scenario, the price paid by the consumer is the result of a series of markups that take place as the product moves through

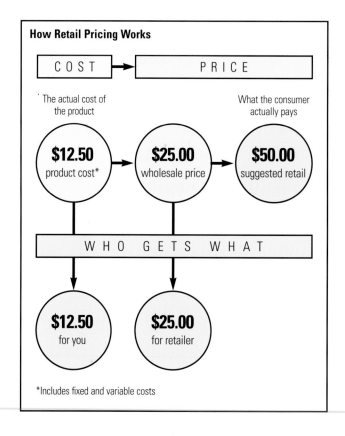

How Retail Pricing Works

COST → PRICE

The actual cost of the product

What the consumer actually pays

$12.50
product cost*

$25.00
wholesale price

$50.00
suggested retail

WHO GETS WHAT

$12.50
for you

$25.00
for retailer

*Includes fixed and variable costs

SETTING THE RIGHT PRICE

Jill Harris of Canyon Design created The Cat's Towel™ in response to her own needs. Before she invented this product, she placed old towels on her furniture to protect it from the shredding and clawing of her cat. It became embarrassing, she says, when friends came over to visit and saw rags strewn across her sofa. So she designed a graphic towel, sized 16" x 25". She integrated the product name into the design so there would be no doubt as to whose towel it was. Today, the towels come in three styles and five color combinations that are intended to work with a variety of furnishings from quaint, to antique to more contemporary.

Harris, who markets these products under the brand name Rabbit Foot Inc., the name of her product design and manufacturing company, appears to have pricing down to a science. Her advice: "Work backwards." She defined the product as an "impulse item," which meant that the product needed to retail for less than ten dollars. Anticipating that this would be a product for resale (she would sell to cat stores and catalogs such as *Cats, Cats and More Cats*, as well as specialty boutiques), she knew how much she had to back out of the suggested retail price to set a fair wholesale price (Hint: 50%) and leave room for a fair profit for herself.

Her approach was right. To date, Harris says she's sold over twenty-five thousand units. She also sells direct through advertising placed in publications like *Cat Fancy* and *Cats Magazine*. Whatever the price, Harris says it fills a real market need. "No more cat fur on black pants," she says. "And for less than ten dollars, it's a real deal, because your furniture doesn't have nine lives."

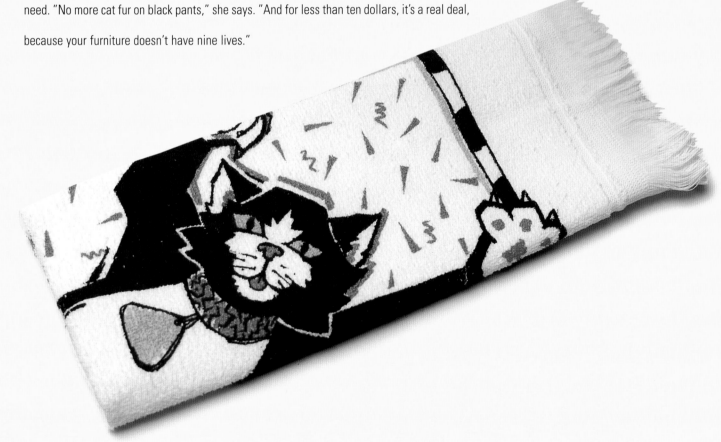

distribution. Industries differ to such a large extent that it's impossible to empirically state what these markups might be. So before you develop your pricing strategy, find out how your industry works. For the sake of this discussion, let's assume that you've designed a product that falls within the broad category of "giftware."

Generally, here's how pricing works. The manufacturing cost, your cost, is doubled. That then becomes the wholesale price. The wholesale price gets doubled again once it gets to retail. This becomes the suggested list price. To state it even more simply, the price of the product gets doubled at each distribution point.

DON'T RELY EXCLUSIVELY ON COST-PLUS

The trouble with a cost-plus type of approach is that it doesn't take into consideration two things: (1) what the consumer is willing to pay, and (2) the potential impact of competition. You'll have to use your judgment on both. What do you think the demand for your product will be? How are similar products in the category priced? In a niche market, competitive pricing will have less impact; but in mass merchandising, competition often drives prices. To that end, think of your cost-plus strategy as a starting point and go from there.

IS IT WORTH IT?

To find out if all the time and energy you'll invest is worth it, you should do a break-even analysis. The purpose is to determine how many units you have to sell to recoup your costs. Breakeven is achieved when you've sold enough product to cover both fixed and variable costs. If sales don't reach the break-even point, you'll incur a loss. With this kind of analysis, you can decide if the venture is worth the risk. Your break-even point can be determined by using the following formula:

You make three mistakes and then you get it right.

—Gary Knell, Studio F. kia

Step 1

[Sales price per unit] - [Cost per unit] = Gross profit per unit

Step 2

[Total fixed expenses] + [Gross profit per unit] = Unit sales needed to break even

This formula assumes that the variable cost of the product is constant. However, various factors such as volume discounts can affect your variable costs based on the number of units produced. Keep that in mind.

PRICE AND ESTIMATING THE PRODUCTION RUN

How can you figure out a pricing strategy if you're not sure how many units you should produce? After all, you need to incorporate all your fixed costs as well as your variable costs into your pricing strategy. You need to estimate the quantity of your production run. The truth is, there's no right answer. "You make three mistakes and then you get it right," says one designer who has designed and introduced more than seventy-five different products to the retail market.

Only experience will tell you how many products you should produce for a first-time production run. Many designers participate in trade shows, bringing with them final prototypes of products ready to be manufactured or having invested in a small production run to get them started. They then determine the first or next production run based on orders received, coupled with feedback they receive from buyers. Obviously if the reactions are "I can sell a million of these," your run will be a little higher than if you hear, "I like this but I'm not sure where I'd put this in my store." Experience is the best indicator.

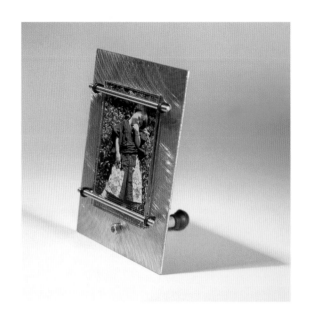

how many units to produce

Wee Me, Wee Us, Wee We from Studio F. kia are picture frames available in three styles using found and raw materials such as stainless steel plate, O-rings, glass and aluminum standoff. They may be found in such stores as The Collector (Merrick, New York), F. kia (Boston), Adesso (Highland Park, Illinois), October Studio (Houston) and Whimsy (Chicago). Initial production runs were conservative.

Wholesale price: Wee me—$11, Wee Us—$16.25, Wee We—$21.50

Initial production run [units]: Wee Me—300, Wee Us—200, Wee We—100

Q-Cards from Zolo Inc. is a deck of fifty-two colorful, offbeat cards that forecast your future. They are irreverent, humorous and highly provocative. They may be found in such stores as Chiasso (Chicago), Alphabets (New York) and Fillamento (San Francisco). Cards were introduced at the New York International Gift Fair and are distributed through Zolo Inc.'s own warehouse.

Wholesale price: $5

Initial production run: 6,000-12,000 units

Object Martini from A-1 Product Co. is a set of two martini glasses. Text on the circumference of the base reads "Warning: Objects in glass may be closer than they appear." Object Martini may be found in stores such as Fillamento (San Francisco), MOCA (Los Angeles), Mxyplyzyk (New York), New York Public Library Store (New York) and Philadelphia Museum of Art (Philadelphia).

Wholesale price: Not available. Retails for $37-$42 per set.

Initial production run: 1,000-2,000 sets (2 glasses per set)

FIRST-TIME PRODUCTION RUNS

How many units should you plan to make? When Benza created its Squiggle mouse pads (see chapter eleven), they produced six hundred units total in three colors. The quantity wasn't established based on anticipated market demand; rather it was the shortest run possible that would make it economical to start production at a reasonable price per unit.

WHEN PRICE ISN'T A FACTOR

There are occasions when the price of the product is irrelevant. That is, if you have a great product. The original Zolo, a creative playsculpture (see pages 30–31), was made from wood, handpainted and handcrafted in Indonesia. The price? $87.50 wholesale. This meant that the toy would retail for around $175. They weren't purchased for kids, claims MoMA marketing director Ruth Shapiro. Rather, her feeling was that they became an adult collectible. Because there was nothing else like it in the market, Zolo garnered a premium price.

WHAT ABOUT CONSIGNMENT?

It's up to you but most counselors will tell you what the TV ads against drugs are telling kids: Just say no. If you agree to make a consignment sale, the buyer doesn't have to pay you until the product sells. You've already taken a big risk by investing in machinery and materials. Let the buyer share the risk with you! As an overall strategy, consignment is less than ideal. However, there may be situations where consignment is the only way for you to establish a presence in a key distribution outlet.

OTHER WAYS PRICE CAN BE DETERMINED

Pricing can be tested. To find out if there is consumer acceptance of your proposed pricing, create a couple of production-quality samples. Get shelf space in a retail location. See if the samples move at the price point you've identified.

The price of a product can also be defined for you by distribution. Working with a catalog company, Tilka Design's Carla Mueller created a holiday product called A Stocking Full of Coal. It was a stocking with a black-foil-wrapped chocolate. The stocking was to be fabricated from velvet. But when the cost of materials was determined, the price was too high. The velvet stocking became cotton. The quality of the chocolate was maintained but it was necessary to scale back other materials to meet a perceptual price barrier.

HOW TO FIGURE OUT IF YOU'LL MAKE ANY MONEY

Want to find out if the whole endeavor will be worth it from a dollar standpoint? The chart below shows you how. The example provided shows the profit/loss of selling 1,000 T-shirts which will retail for $25 each in a high-end, specialty store. The example assumes that the product is sold, by you, directly to retail outlets.

A simple profit and loss statement		$ per unit	Sub Total	Total
Estimated Revenue	1000 shirts	12.50		12,500
Fixed Costs*				
Rent, etc.		.25	250	
Variable Costs*				
Cost of T-shirts	1000 shirts	5.00	5,000	
Silkscreening	Flat rate from friend	3.00	3,000	
Packaging/Shipping	Bulk ship/UPS ground/84			
	shipments @ $5 per	5.00	420	
Marketing		00	1,000	
			9,420	
Total Cost				(9,670)
Profit/Loss				**2,830**
*Assumes you do most of the work yourself				

DISTRIBUTION: WHERE TO SELL YOUR PRODUCT

Now that you've determined the price of your product, it's time to decide which channels of distribution you'll use to get your product to market. For starters, see chart Distribution Channel Alternatives (page 87). If you've created a specialty product and are in the start-up phase,

you'll probably want to consider Channels 1, 2 or 3.

Channel 1

The first channel represents a direct sale to the consumer. It's short, simple and fast. Do you remember the Fuller Brush Man? The Avon Lady? This channel has also been successfully utilized by graphic designers that want to (a) maintain as much control as possible in all phases of the product design and marketing process and/or (b) find that this is the best option to appeal to a distinct target prospect base that is identifiable and reachable. For example, Walking Man (featured in chapter three) is sold direct to customers primarily through direct mailings. Similarly, because John Clark, owner of *Clark's Register*, is interested in reaching an upscale, male customer, he has opted to sell direct.

Channel 2

Many manufacturers have opted to sell their own products directly to consumers, and have also become retailers themselves. Consider the outlet stores created by such brands as Anne Klein and Ralph Lauren. Walking Man has successfully employed this distribution channel by turning its warehouse into a showroom that also offers retail sales. Retailing requires a special expertise and different business skills than running a design practice. Know up front that it's a tough business to be in.

Or, rather than "own" your own retail outlet, you might consider selling direct to retail outlets. For example, when Jane Timberlake started A-1, she achieved early success by selling direct to a museum store. In fact, that's how many graphic designers have gotten their start in product marketing.

The next three channels involve intermediaries or middlemen who will be looking for compensation for their contribution in facilitating a

product sale, versus a direct sale made by you where all the profit goes to you. Take this into consideration as you determine which channel is most appropriate.

Channel 3

This channel of distribution involves working with a sales agent who sells your product to retailers. This channel is utilized by designers who have products in the giftware category who may rely on sales reps to call on gift stores, museum shops, etc. This type of distribution is utilized by design firms more often during start-up.

Channel 4

This method of distribution—through sales agents that sell to distributors and then to retailers—involves lots of layers of intermediaries. The more layers involved in the distribution chain, the less control you'll have and the more of potential profit that winds up in the hands of others who may or may not add value along the way.

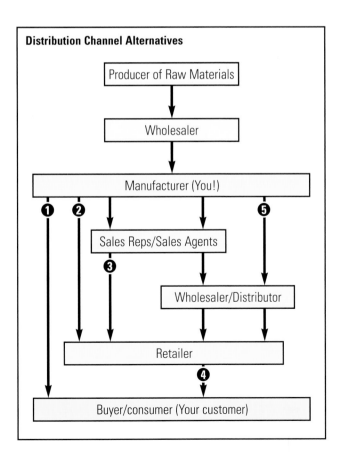

BRANCHING OUT INTO NEW MARKETS

Sandra Higashi and Byron Glaser form Higashi Glaser Design, a multi-disciplinary design firm. Together, they founded Zolo Inc., a product design and manufacturing company named for their most successful product, Zolo, a creative playsculpture.

Since the invention of Zolo, Higashi and Glaser have created toys, fragrances, personal care products, gifts, furnishings and furniture, tabletop, kitchenware, home accessories, even computer games. To date, they have designed and marketed more than twenty-five products all under the Zolo Inc. brand. No matter how diverse the product categories, the products themselves share many common traits: a sense of playfulness, a sense of humor and a keen sense of design. All products are nongender driven and many offer a dimension of interactivity. What inspires them? "More satisfying than anything by far," says Higashi, "is when kids tell us Zolo is their favorite toy, or when someone tells us a personal story about how one of our products has enhanced their life." And, adds Glaser, "We've heard stories about people falling in love because of Applied Chemistry (see Introduction) and how Kooky Cutters made someone's party."

Their track record proves it's possible for a small company to successfully design and market products to more than one industry. Before Higashi and Glaser venture into any new category such as with the development of Zoop, the pair's first foray into computer games, they find out everything they can up front. They learn how products are distributed, how the industry works and meet with key players. "We decide what we want to do and then we figure out how to do it," says Glaser. Zoop was nothing more than a playstructure when ViaCom first approached the design team. They added the concept, created the environment and the entire look for the game.

Higashi notes that there is but one criteria they consider prior to initiating product development, "Does the product meet an unmet need?" Sometimes, she notes, like products exist. In that case, "What we add is a new visual or graphic twist," she says. Other times, their products break new ground (Zoop earned top marks from *Wired Magazine* and other industry pundits). Adds Glaser, "No matter what medium it is, and no matter how different it is from what we've done before, we always approach it with the same principles of concept and design."

If possible, avoid the Channel 4 type of distribution structure.

Channel 5

If you don't have plans to create your own sales force but need national distribution, hooking up with a distributor or wholesaler may be a viable option. Wholesalers can provide geographic reach that might otherwise be impossible. But this channel is primarily utilized for more mass market types of products. You must be willing to sacrifice a smaller gross profit for your product.

OTHER CONSIDERATIONS

As you think about creating a distribution program that meets your needs, there are three things you'll want to consider:

Coverage

What kind of market coverage do you need? Start by identifying your target customer. The bigger the potential base, the more coverage is generally needed.

Control

The level of control you'll be able to have is contingent upon the distribution channels you utilize. Selling directly to consumers will theoretically provide you the highest degree of control possible.

Cost

Factor in the costs associated with different channels of distribution. What will the various intermediaries take as their piece of the pie? How will that affect the final cost of the product? How will it affect your profits? Logic would say that the more direct the route to the consumer, the less time it will take and hence, the less it will cost. However, if you go direct, you must consider that the costs normally absorbed by distribution (cost of inventory, cost to store finished goods, promotion, etc.) are to be incurred by you.

Markup. The difference between cost and selling price.

Merchandise Mix. The range of items which are sold within a given store or venue.

Net Profit. Total income minus production and other expenses before taxes.

Net Sales. Gross sales minus expenses (returns, discounts).

Net Terms. The amount of money that is due without any discount.

Niche Market. A specific audience for a particular type of product.

Operating Costs. The costs that you incur day-to-day in the business.

Overhead. The costs which are involved in a business that aren't directly related to the production of merchandise.

Physical Inventory. The actual cost of merchandise on hand.

Price Point. The dollar amount of an item.

Profit and Loss. A financial account of income and expenses for a specified period of time

Purchase Order (PO). A confirmation between the buyer and seller of the order.

Quantity Discount. A reduction in price given for large orders.

Retailer. Someone who sells products directly to the consumer/buyer/user.

Return on Investment (ROI). The percentage you earn relative to the capital investment.

Revenue. All income produced from sales.

Sales Representative. A person who sells your products on commission.

SKU. Stock-keeping unit. Each single item or product is a sku.

Suggested List (or Retail) Price. The price point at which the retailer is expected to sell the merchandise or product.

Turnover. The frequency with which an item or sku sells. The faster a product "turns," the faster cash comes back.

Variable Cost. The direct costs to produce your product.

Volume. Annual gross sales.

Wholesale. The selling price to the retailer.

Wholesale Manufacturer. Anyone who makes, markets and sells their products through distribution channels.

THE PRODUCT MAY DICTATE DISTRIBUTION

If you're like most other designers who have gone this way before, you are probably interested in one of the following markets: tabletop, personal care, giftware, decorative accessories, furniture or greeting cards/gift wrap/stationery, etc.

In that case, your distribution will be defined by the type of product you choose to create. Example: there are only so many types of stores/outlets that would take on an innovative tabletop line such as Jane Timberlake's Wild Mannered Dinnerware (see chapter one) or her whimsical martini glasses shown on page 82.

Niche products, like Timberlake's, are specialty products that generally don't end up in retail chains or mass market outlets. Generally speaking, niche products will be sold either direct to consumers (by you or other direct venues such as catalogs), or to retail outlets such as specialty stores, museum shops, gift purveyors and/or decorative accessory stores. As always, there are exceptions. For instance, a picture frame you design might be perfect for Pottery Barn or Banana Republic, both national chains. Fortunately, there are a number of trade shows which you can utilize to cost-efficiently reach these types of buyers (for more information, see pages 118 and 141). A Web site or home page may also be cost-efficient.

Another exception is the furniture category. Unless you are prepared to underwrite tons of expensive equipment or desire to produce limited-edition pieces, you might be more inclined to license your idea to a manufacturer (for more information, see chapter five).

WHY THE GIFT BUSINESS MAKES SENSE

The gift industry doesn't experience the same ups and downs that other industries do. Even when the economy is down, birthdays, Mother's Day and anniversaries rank high on consumer priority lists.

financing

Be prepared. That's the best advice anyone can give you when it comes to obtaining money, whether it's raising capital to fund your first production run or planning ahead to anticipate your cash-flow requirements.

If you've come this far in the product design process, chances are you have a product idea that you really believe in. That counts for a lot. So you have two options:

1 You can either invest in yourself.

2 Or you can convince someone else to invest in you.

Before you seek financing, consider first if you already have the resources at your disposal to finance your product design and manufacture your product without going to outside sources.

INVEST IN YOURSELF

One way to look at financing is to consider yourself as an investment. Let's take a look at what you might earn if you invest your money in your own product versus socking away money in a Certificate of Deposit (CD), a savings account or another conservative investment tool. Let's say you set aside roughly $200 a week for a year.

If you deposit $10,000 in an investment that yields about 8%, after one year you would earn $800.

$$\$10,000 \times 8\% \ (.08) = \$800$$

RETURN ON INVESTMENT (ROI)

But what if you had taken $9,670 of the $10,000 and invested it in the design and manufacture of a product of your own design? (Please see the example on page 85 in chapter seven.) If you had designed and

sold 1,000 T-shirts per the example, you would have made a profit of $2,830 if you had sold all of the shirts. That's a return on investment (ROI) of 29%. Here's how the calculation works:

$$\frac{\$2,830 \text{ (profit)}}{\$9,670 \text{ (cost/includes both fixed and variable costs)}} = 29\% \text{ ROI}$$

But what about your blood, sweat and tears? After paying yourself a fee of $2,000 for the design of the shirts, your "investment" has still performed better than the original example.

$$\frac{\$830 \text{ (\$2,830 profit} - \$2,000 \text{ fee} = \$830 \text{ profit)}}{\$9,670 \text{ (cost)}} = 8.5\% \text{ ROI}$$

Of course these examples are painfully simple for the purposes of illustrating the concept. And obviously, there's a good deal more risk in starting your own manufacturing company than there is in plunking your money in a 6%-return CD account. But run the numbers for yourself using the formula provided in chapter seven and the ROI formula provided above. Factor in your own discretion, willingness to take a risk and common sense. The idea here is to get you to think of yourself as an investment. The smart money is on you and the theme is "invest in yourself." If you don't believe in what you can do, how can you convince someone else to? There's another reason to fund your start-up with your own money. As one designer put it, "There is nothing like investing your own money to make your senses razor sharp." Once you enter the world of manufacturing, you will find that a penny added here and a penny added there can have a big impact on your profit margin. If you spend an extra $.20 per unit and produce 10,000 units, that's $2,000 in cost. It adds up quickly.

Don't hold your breath for a return on your investment. It takes time but in the long run it really pays off.
—McRay Magleby

Having said that, you may not be rich as Croesus, and you still may need financing of one sort or another. You still have some options.

If you're looking to borrow, you'll need a business plan. No surprise there. The focus of your plan should be on potential growth. It should include a detailed payback plan and a realistic time frame. Investors or guarantors will want to see what your cash flow will look like and that you have been realistic in your calculations. Think through those numbers carefully. Then, ready your personal tax returns. Bring along your business tax returns. The more you can impress them with your planning and preparation, the more they will have faith that you will repay your loan and the greater the chance that you will be approved.

START WITH YOUR BANK

Many graphic designers interviewed in the course of writing this book have relied on their own savings or loans from friends and relatives to finance their start-up, complaining that financing is a "Catch-22," that "you can't get money from a bank until you have money." But there are things that you can do to make the process easier if you prepare ahead. First, you should make a point now to develop a personal relationship with your banker (if you own your own design practice, cultivate the contacts you already have; if you don't, establish a relationship). Don't wait until you need money. Let your banker know what you're doing early on. Invite your banker to business functions; make him or her feel like an important part of the success of this venture. Establish a track record.

DON'T FORGET CASH FLOW

Jane Winsor and Stephanie Logan meticulously planned their business down to the last detail. They are the founders of Yaza, a giftware products company based in Cambridge, Massachusetts, known for gift wraps that feature flying coffee cups, and blank journals that showcase Winsor's effervescent illustrations. They funded their start-up with a loan from Logan's mother and Winsor's personal savings.

For the first couple of years, the business ran smoothly. Orders were small and the stakes weren't high. If Yaza ran out of a product in their line they could quickly assemble a few extras here and there and cover the costs from their own pockets. As the stakes got higher, however, the full-time manufacturers faced new challenges. The biggest: cash flow, the amount of cash available for operating expenses. If business is seasonal—or if there's a long gap between payables and receivables—cash flow can be a struggle. "I'm a designer," moans Jane. "I never thought I'd have to deal with things like this."

In Yaza's experience, cash flow is key. "It's the first thing that can kill a business like ours," says Winsor. She says that to be successful, "you have to think of your inventory as dollar bills because by the time you run out of cash, it may be too late." This is difficult, she says, considering all the balls one must keep in the air. Winsor's solution: "Keep your inventory tight." To manage money, Winsor advises:

- Find suppliers who will work with you, even if you have to pay more. Yaza's photo album line was originally sourced overseas. The product took thirty days to manufacture and an additional thirty days for transit. "This was deadly," she says. Yaza had paid for product up front, but there was a two-month gap between order and delivery. And an even longer period of time considering their own selling cycle.

- Take a line of credit.

- Work with a factoring company (a form of borrowing or financing where you sell your receivables for a discount before they are due). Use this as a last resource.

- Track your inventory. "You have to be disciplined about it," says Winsor, "and you have to stay on top of it." It's easy to get an order at the end of the day, fulfill it quickly to meet the need and then forget to log it. The same goes for samples (used for PR, marketing, etc.). "You have to track everything," she emphasizes.

To keep inventory tight, Winsor counsels:

- Take physical counts. Yaza's manufacturing operation includes piece work (example: blank journal and address book covers are preprinted and stored off-site. As orders are entered by Yaza, a call is placed to a third party to assemble the needed number of units). Unless a physical count is taken on-site at each stage of the production or assembly process, there is no way of knowing

why a certain item might run "short." Winsor says you should send in your own person to do physical counts. "It's a habit you must get into. Otherwise, you'll ask a supplier why you're short and the answer will be 'don't look at us!'"

- Utilize software that will enable you to have total inventory control, from order processing to invoicing and automatic inventory management. Again, Yaza's experience is invaluable. To anticipate their growth, the partners purchased a complete inventory package (Oakstreet by Industrious Software). "It was the worst thing we ever did," notes Winsor. The software wasn't bad. What happened was that to get the system operating properly, the partners invested at least ten hours a week over a six-month period."We should have built the system gradually," she says, "and we should have taken one module at a time, starting with order processing and working from there." (Before you select a software program, determine your specific needs and check with your accountant to confirm reporting requirements.)

Venture Capital

Venture capital can be very expensive. A venture capitalist will generally desire an equity position in exchange for financing, which means you're giving someone else a stake in your business. Venture capitalists are more often associated with high-growth, high-tech companies, but there are some that are interested in backing start-ups with good growth potential. If you want more information, you might start your search on-line. You'll be deluged with choices. Yahoo's directory (www.yahoo.com) will give you at least a couple of hundred documents on the topic. InfoSeek (www.infoseek.com) will give you more than a thousand. So make your requests very specific.

Other Sources of Capital

The Small Business Administration (SBA), of course, is another resource for start-ups. You can check with the local SBA office in your community for more information. You can also call the SBA (800-827-5722) to get publications, pamphlets and other information that is financing-related or of general interest to small businesses.

Less well-known is that the SBA licenses Small Business Investment Companies (SBICs)—government-backed private venture capital firms. Traditionally venture capitalists seek fast growth and fast returns. Conversely, the mission of SBICs, according to *Inc.* magazine, is to bring home solid returns for companies with annual revenues less than $10 million. Last year, Congress dramatically increased the agency's commitment for SBIC investments by 57%, to $657 million in 1997 from $374 million in 1996. By law, SBICs are required to invest in U.S. companies with net worths of less than $18 million and after-tax earnings of no more than $6 million. Plus, a full 20% of the loans must be placed with even smaller companies with

capital

earnings of less than $2 million. In 1995, 36% of the dollars went to manufacturing companies.

"My experience with the SBA is that you should expect a lengthy process and a lot of paperwork," says CPA Christopher Forbes, a partner in Connecticut-based Courtney, Fink & Forbes. "Plus, you may need the help of a lawyer and an accountant, which adds additional expense." Forbes counsels his clients to start with a bank and establish a line of credit.

Loans

A line of credit on your home, if you own one, is a ready source of capital. Be careful to check on any usage guidelines. The banker who learns that your alleged home improvement is actually five hundred sets of designer martini glasses, may be a bit troubled. Tip: If you plan to quit your design practice to get into product design full time and think a line of credit makes sense, apply for it now while you still have real income!

Find an angel

If you do pro bono work for nonprofits in your city or community, spread the word that you need help. Board members of many nonprofits are already successful business people or may be well-to-do. The notion of helping someone else to create, launch and market an entirely new product may cause someone to open their wallet. Ask friends, relatives, Mom and Dad. Ask anyone who believes in you, has money and is willing to assume a little risk. A word to the wise: Don't borrow from anyone who'll see red if your venture doesn't quickly get into the black.

lenders

Use your credit

These days, it's easier than ever to get credit cards. If you need some quick cash, there's a ready supply of money waiting for you in the form of "cash advance" if you're willing to pay the hefty interest rates. Be careful not to overextend yourself. It's not "free" money. Forbes suggests you avoid credit card advances to fund start-ups. "You don't want to jeopardize your personal buying power," he notes. If your new product venture runs into cash flow problems, you may need to tap into your credit cards to help put food on the table. As such, Forbes counsels his clients to "use them as a last resort."

FINANCING OPTIONS FOR DESIGN FIRM OWNERS

If you own your own graphic design practice, there are a number of things you can do through your business to fund your new product venture.

Progress Billing

If you're not already in the practice of advance billing your clients against work in progress, get into the habit (even if you decide never to get into product design, it's a better system to even out your cash flow). Most clients understand the concept of billing in thirds as long as they are provided with an estimate up front. Bill one-third of the total of the job at three phases: (1) one-third to start work; (2) one-third upon approval of design; and (3) balance upon completion. Progress billing gets usable cash in the door earlier. If a project takes three months to produce with a budget of $45,000, by the time the project is completed you already have $30,000 in the door. The purpose of progress billing is to provide better cash flow to fund your ongoing expenses.

Leverage Suppliers

You probably have a pretty extensive network of suppliers and vendors you work with including printers, silkscreeners, fabricators, photographers, etc. Presumably they value the relationship they have with you and may be willing to help you. There are at least three ways you might take advantage of your relationships with these people. First, you can ask them to extend payment terms to an agreed-upon date. Getting a supplier to agree to hold billing for an extra thirty to ninety days may give you the capital you need to get started. Next, you can ask them to help you produce your product at their cost, with additional monies to be paid when product is sold. Agreements that get suppliers to share—in one way or another—in the ultimate success or failure of a project helps to make them more accountable. In fact, it often enhances the quality of work because they have become stakeholders in your success. Finally, you might try renegotiating the way you compensate suppliers. Is it possible to place a substantial percentage of your firm's printing at one firm in exchange for volume discounts? If you can save 10% on $250,000-$500,000 worth of printing for a one-year period, that's $25,000-$50,000 of working capital!

Line of credit

Use the clout you already have with your design practice to obtain a business line of credit.

CASH FLOW

No matter what else you do, you must make an attempt to create a cash flow projection. It doesn't need to look fancy but you do need to know when you will be taking money in so you know when you have money to spend. It's also an important tool to help you forecast how much money you will really need to launch your product and sustain

your marketing support for a specified period of time. One of the biggest reasons businesses fail is their inability to correctly project cash flow.

As you fill in the Cash Flow Projection Worksheet, remember—cash isn't real until it's in your hands. An order isn't cash. An invoice isn't cash. A purchase order isn't cash. A check isn't cash—at least not until it's deposited and cleared. Only cash is cash. Don't count money as cash until it's really in the door.

When you're figuring out cash flow, you'll want to project when orders will be received (factor in shipping time, etc.). And then figure that it will take from thirty to ninety days once the order has been shipped and received for you to receive payment (unless you're selling direct and are utilizing some form of credit card payment). As you start to track your receivables, you'll know who pays at thirty days and who doesn't. Tip: Bill before you ship goods to minimize the lag time.

As you are trying to determine when orders will come in, factor in "seasonality." For example, if you are creating a product in the "giftware" category, you will find that the key national trade shows you might attend are in February and August. If you plan to attend the show and take orders, those months, or the immediate weeks after key show dates, will obviously reflect higher order patterns than other months during the year. If your product is holiday-related, you can expect a burst-buying pattern versus orders placed consistently week after week.

cash

flow

Cash Flow Projection Worksheet

	Jan	Feb	Mar	Apr	May	June	July	Aug	Sept	Oct	Nov	Dec
Income												
Product No. 1												
Units Ordered												
Units Shipped												
Total Income												
Expenses												
Fixed												
Salaries												
Taxes												
Equipment												
Rent												
Utilities												
Variable												
Raw materials												
Conversion expenses												
Assembly costs												
Labor/subcontracted svcs.												
Cost of sales												
Cost of returns												
Packaging												
Freight												
Marketing expenses												
Total Expenses												
Net Cash Flow												

Note: This chart is oversimplified to demonstrate how cash flow works.

a sweet

of

symphony

delicate

rain

will

flood the sky

CHAPTER 9

At this point, you've done all the legwork. You have a great product. You've found money. You're ready to go into production, right? Wait!

production

Even though logic tells you to manufacture your product before you sell it, that's exactly what you don't want to do—not unless you have to. It's tricky to pull this off but the reverse is the way to go if you can. It's more prudent to market your product first and then produce it quickly. Or produce a very small quantity at the outset. Before you invest in expensive machinery and pricey materials to go into full-scale production, find out if the product is salable. Nevertheless, you need to be ready to go into production at the drop of a hat.

This chapter will help you

(1) Create a production schedule

(2) Establish quality control parameters

CREATE A PRODUCTION TIMELINE

Determine each of the steps that will be required to produce what you think will be a reasonable quantity of product. Identify lead times for materials and supplies you will use. Identify turnaround times for the components you will need to outsource. Check with each of the suppliers you plan to work with for turnaround times. It is helpful to make a comprehensive, step-by-step list.

As you develop your timeline, ask yourself: Is there a faster way to do this? Is there a smarter way to do this? Is there a more economical way to do this? Be sure to factor shipping and handling into lead times. Also, be sure you understand in what form materials will be shipped to you. Will the cardboard boxes arrive prefolded or will you have to fold them yourself?

To meet overwhelming demand you have to have fat enough margins to finance fast growth—don't be afraid to charge a premium price! If people want it, they want it…they'll pay more than you think.

— Dave Kapell
Magnetic Poetry, Inc.

SO SIMPLE TO ASSEMBLE YOU CAN DO IT WITH YOUR EYES CLOSED

Cubizm® is a multi-personality wood-block toy. It is shaped as a cube and made with stickers. Both Sandra Higashi and Byron Glaser thought it would be simple to assemble.

"We thought you could get a sticker that would wrap around all sides of the cube and that it would take maybe a minute to do one," says Glaser. "It seemed so simple that you could do it with your eyes closed," adds Higashi.

Instead, the product required skilled labor and painstaking hand construction—time and expense that was not factored into the product cost. Higashi cautions that each time you start something new, you're bound to run into a glitch or two. "You learn as you go," says Higashi. "You have to expect that when you're trying to create something that's never been done before."

Determined to make a great idea work, the team went on to develop Expressionizm™, which utilizes some of the same compo-

nents of Cubizm, but in a different form. It's a thirty-five-page, multi-personality portrait book designed to stimulate freedom of expression and the art of play. The kit includes fifty-four provocative stickers. "This time, we got it right," says Glaser. Expressionizm, introduced in 1994, has sold more than seven thousand units.

Your credibility, the first time out with a new product, is on the line. If your product is flawed in any way you may not see buyers coming back. It doesn't matter how great your next idea is. If you don't deliver the first time, you will kill the opportunity to get repeat business. From your experience as a designer you know that it's far easier to retain customers than it is to get new ones. The first thing you have to do is set high standards. To implement a quality control program you can:

- Create a perfect sample and use it as the standard by which all other pieces are to be judged.

- Make sure that each component of your product is inspected and OK'd at critical assembly points.

- Make sure that every finished product is checked carefully.

- Maintain detailed records of the production process. Take photographs of your product at each assembly stage and record the suppliers and subcontractors who were involved. Include material samples, color chips, fabric swatches, etc. Note all sizes and specifications.

- Meet with each of the suppliers and subcontractors involved in the product manufacturing process. The more each understands their contribution to the whole, the better the final result will be. It's important for suppliers to physically see how sloppiness on their end or shoddy work will affect the finished piece.

- Standardize as many of the production procedures as you can.

- Try to minimize the number of times that a component is physically touched. The more material is handled, the more susceptible it is to damage.

- Don't let anything go out the door that doesn't reach your high standards.

MAGNETIC POETRY: NOTHING TO SNEEZE AT

In 1992, David Kapell was making $15,000 a year as an administrative assistant in a wholesale produce house in Minnesota. A recent English major, Kapell wrote poems and songs on the side. Every now and then, he'd take a page of writing and cut it up to mix the words around, his solution to writer's block. But Kapell had allergies and was prone to sneezing fits. Aaaaaaa-choo! Scraps of paper flew everywhere. It occurred to him that if he could glue the words to magnets and stick them to something metal, like a cookie sheet, it would prevent them from blowing around. A roommate had brought home some advertising magnets from a local pizza parlor. Magnetic Poetry was invented. Soon, friends wanted poetry kits of their own. Production began.

Armed with a laser printer, magnetic sheets, scissors and glue, Kapell made 100 kits and priced them at $14 each. He took them to a local crafts fair, expecting them to last the whole weekend. They sold out in three hours. He was on to something.

Kapell assembled an emergency work party. The production team, his friends, stayed up all night making more kits for the next day. He raised his price to slow sales. It didn't work. He sold out again. In December of 1994, barely a year after he began, he sold 18,000 kits. They were no longer made by hand, but by machine. How did he do it? He made the rounds of Minneapolis-area screen-printers and die shops, got a crash course in manufacturing, and was lucky enough to find a call-it-like-it-is sales rep named Murray Condon from a St. Paul graphics company. With $5,000 saved from his craft fair sales, Kapell bought dies and produced 1,000 prototype sets.

Early on, one of his biggest frustrations was meeting the huge demand. His manufacturer bumped his work down the production schedule any time a bigger client walked in. With orders exceeding 20,000 units a month, Kapell decided to take over manufacturing himself.

Kapell teamed up with the man who had helped him with his early prototypes. They formed a separate company called Screendoor Graphics. The company was funded by Kapell; Condon brought the expertise. They purchased a screen press, dryer line and other equipment. Their goal was to achieve a three-day turnaround from order to delivery.

Inventory control was another challenge. There was no system in place. They would run out of labels, pay a premium for rush orders and also lose valuable production time. The solution? They brought in an inventory control specialist.

Magnetic Poetry fulfills an expressive urge in people to be creative, intellectual—even silly. These magnetic nouns, adjectives and verbs inspire even the most stalwart to wax lyrical.

Magnetic Poetry's sales reached $900,000 in 1994 (first full year), nearly tripled to $2.5 million the next year and more than doubled in 1996 to $5.2 million. In 1997, Kappel expects to hit $6.3 million in sales. Now that's nothing to sneeze at.

Can you create an assortment?

A company that offers more than one item is more valuable to buyers. Think about what kind of choices to your core product you might give buyers. Variations on products might include color, pattern, materials used, size, style or any combination thereof.

How will you store materials?

If you don't have the space to store the goods you need to execute a production run, you will need to look into warehouse space. Look for a bonded warehouse, one that is insured against the loss of stored goods. Or, perhaps one of your suppliers is willing to store materials for you at a special rate.

Order fulfillment

Buyers may want to place a "blanket order" with you. This is to guarantee the buyer that the stock they want will be available. The idea is that they can "draw" smaller orders against a larger order when they want to (often during a season). Be prepared for this.

Inventory management

As a manufacturer, good inventory management is essential to your success. Too little inventory means you may not be able to deliver product in a timely fashion. Too much inventory costs money. Though you probably won't need to do this for your first production run, you should start tracking your sales. There are at least a couple of off-the-shelf software programs that will log sales and match inventory projections to production. One that comes highly recommended by the partners of Studio F. kia is Manufacturers Automated Clerk from Industrious Software Solutions (800) 351-2445 (it is not clear at the time of this writing whether this software program will continue to be supported by its creator). Partner Gary Knell describes it as a good

In 1991 we were unemployed and looking for work in the field of architecture. We had made some picture frames as gifts and were encouraged by a friend to sell them. A distributor brought them to a gift show and took orders for about twelve thousand dollars and we've kept going since.

— Gary Knell, Studio F. kia

PRODUCTION RUNS

How do you know how many units to produce for an initial production run? The answer is "it depends." The production run for the original wooden playsculpture Zolo was 12,000 units. It was manufactured by Zolo Inc. and distributed exclusively by the Museum of Modern Art, New York for the first two years. In 1993, Zolo was licensed by Lucas Toys and manufactured in plastic by Ertl. Despite winning Playthings *and* Family Fun *magazine's "Toy of the Year Award," Ertl had management changes and failed to renew their contract. Zolo was picked up in 1996 by Wild Planet, a smaller and very progressive toy company. The estimated production run for this later version is 250,000-500,000. Find out what other designers have done to anticipate demand for different types of products (see chapter seven).*

WHAT IF YOU HAVE A BAD PRODUCTION RUN?

Once you actually do move into production, you may produce some product that would be considered "seconds" or imperfect. Don't ship bad product to customers! Instead, consider offering the lot to a single buyer at a special rate. If you can sell the less-than-perfect product through a distribution channel you wouldn't normally utilize, all the better.

program if you're starting out. In this program, inventory is linked to invoicing. When you send an invoice to a customer, the program subtracts the items from your inventory. You can also program "safe levels" so that you will be alerted if inventory is running dangerously low.

Select a carrier

Not only are you responsible for designing and producing a perfect product, you are also responsible for getting it to your customer in pristine condition. The next step? Research and set up a packing and shipping procedure. To do this, source appropriate protective packing materials. Additionally, research delivery services that will meet your needs. No matter what carrier you use, check their insurance coverage to be sure shipments will be adequately covered.

Do you need a merchant account?

If you're planning to sell direct to consumers, you will need to consider which credit cards you will accept to ease the payment transaction. Now is the time to start investigating. Visa and MasterCard are the most logical starting points. For either, contact your bank and tell them you want to set up a merchant account. Shop around; rates vary. If you'd like to also offer your customers the option of American Express, you can call the company directly. It takes about ten to fifteen minutes over the phone for them to take your application.

In general, discount rates are available. They're based on gross sales and whether you submit your records electronically (more discounts apply) or on paper (more expensive because the chance of fraud increases). For additional information:

MasterCard—www.mastercard.com

Visa—www.visa.com.

American Express—(800) 445-2639 or (800) 528-5200

Starting the company and knowing nothing was one of the best things that could have happened. We jumped into everything we could and didn't know what to expect—forcing us to learn quickly.

— Marcello Albanese
Studio F. kia

marketing

The product launch stage is critical. How you handle it may mean the difference between success and failure of your product. If your product is truly new, you may also have the responsibility of stimulating primary demand—educating consumers and buyers as to what this product category is and why it's relevant.

Assuming, again, that you have designed a product that is niche-market focused and that you want to sell it at retail, the single most important thing you must do is to find out how to reach the potential retail and wholesale buyers. Each industry is different but the best way to find the right buyers for your product is to ask. Solicit the input of retailers, wholesalers, sales reps and other product designers.

Once you've identified key buyers, you are ready to launch your product. As such, this chapter is divided into two parts.

(**1**) The first part covers the essentials: the indispensable items you must have to support even the barest-of-bones product launch.

(**2**) The second part covers exposure: how to create maximum visibility for the fewest dollars. Special considerations for direct-response marketing are included at the end of the chapter.

ESSENTIAL TOOLS

Start with the basics. You need an order form and a price list. Before you create them, think about all the paperwork you fill out every day. Keep it in mind as you create the fundamental tools that will provide the foundation for your product marketing efforts. The easier you make it for buyers, consumers and the trade to do business with you the more they will want to do business with you.

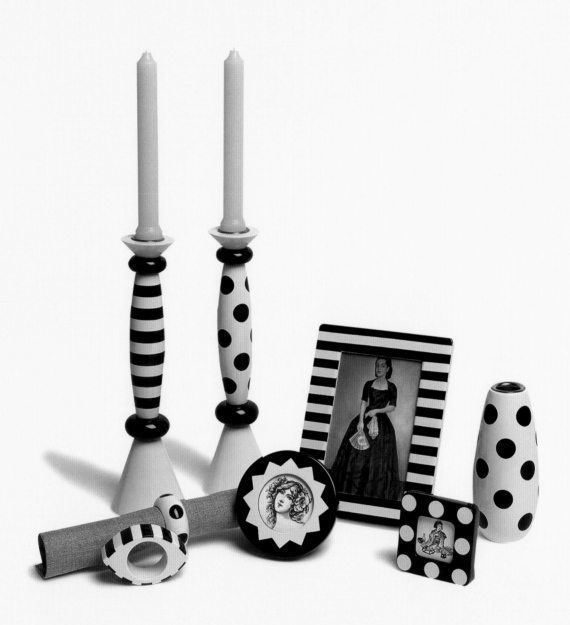

THE CLUE TO SMART MARKETING

Arthur Wang is always one step ahead of his competition. The former graphic designer and founder of The Clue Company searches endlessly for new materials, and new ways to utilize traditional materials. This is particularly challenging, Wang admits, because "everything has been done."

Still, Wang manages to completely reinvent product categories with each new line he creates. For example, gift packaging is as old as giving gifts. But Wang combined high style and low tech with the invention of New Attitote—reusable packaging, configured in inventive shapes and made of recycled material. He's a proponent of versatility, too. A line of resin bud vases double as candleholders. His resin picture frames, called The Clue Picture Frame, look like perfume bottles. From Wang's perspective, the first rule in successful product marketing is designing products with distinction. "People tire of things very quickly," he notes.

Marketing is important to Wang. For the debut of his Retro Collection and Retro Lamps, Wang was handpicked to be included in the prestigious Accent on Design section at the New York International Gift Fair. The line, which includes frames, vases, candleholders and napkin rings in a variety of colorations and patterns, is fashioned from Bakelite, the brand name for the first thermosetting plastic invented by Leo Hendrik Baekeland in 1907. It was later popularized in the 1930s for items such as jewelry. With this line, Wang challenged the boundaries of material and craft by reinterpreting the material with a clean, sleek, modern sensibility.

In addition to having a presence at this trade show, Wang handpicked sales reps to represent his line in select geographic territories. "It's very hard to find a good rep," he says. "You want someone who will represent you well, has a good reputation and will help you reach more markets." Wang advises looking for reps that are credible, have strong experience, good customer lists and "can help you open the door to the right accounts." By general trade practice, reps typically earn 15% commission on the wholesale price of the product. "A good sales rep is worth it," Wang adds.

The Clue Company's marketing arsenal also includes advertising in interdisciplinary design publications such as *Metropolis*. This enables Wang to maintain a presence among buyers, build credibility and pull sales into stores. Because his product line changes so quickly, Wang admits it's a challenge to keep marketing materials up to date. His "catalog" is a series of product line spec sheets which feature full-color product photographs and product descriptions, designed in a way that affords him the ability to make instant changes when necessary.

With orders from upscale stores like Henri Bendel, museum stores like the Chicago Art Museum and the American Craft Museum, and upscale gift stores and boutiques nationwide, Wang works hard to strike a balance between meeting demand (he always has more orders than product), maintaining high standards (product quality is tantamount) and making a difference (Wang is adamant that his work must rise above the ordinary).

Order form

Design the order form as simply as possible to enable a buyer to easily purchase your product. Your order form can also function as an invoice/packing list. (Many retail buyers will use their own purchase orders but this should not preclude you from standardizing your own materials.) Here's what the order form should include:

- Company name, address, phone and fax. E-mail is optional.

- Billing address of the customer.

- Contact name.

- Shipping address.

- Date of order.

- Delivery date.

- Description of product. Leave room for options that are critical such as product name, item number, color and size.

- Price. Include room for cost per unit and total.

- Finance charges. If invoice is not paid within specified time frame, what finance charges will be incurred by the customer? 1.5% per month is standard.

- Payment requirements. You may want to include COD for a first-time order or "Net 30," which means that payment is due in full at thirty days.

- Freight terms. Specify if freight is included in price and identify freight options.

- Return policy. What is the time limit for returned goods and how are returns handled?

If you are planning to sell direct to consumers, your order form will then need to include room for the credit card number, expiration date, cardholder's name and cardholder's signature. You will also need to include room for sales tax, where applicable.

Price list

You will need a price list whether you intend to sell direct to consumers or to the trade. Publish your price list separate from other promotional materials or design a catalog that is flexible enough to accommodate change. Be sure to set up your price list from the buyer's point of view. What is the easiest way for them to order the items they want?

Identity

To the outside world—consumers, retailers, wholesalers, distributors and even suppliers—you are a new entity, no matter what name or iconography you use. As a designer, you already know the importance of identity materials and the value of making a strong first impression. Quality counts. Make sure you have the core identity materials needed to give you credibility.

Catalog or Sales Materials

If you don't plan to sell direct to consumers, the only personal contact you may have with buyers is at a trade show. The better your image and sales materials, the better the impression you will leave. Some type of vehicle to visually present your product is necessary. It may take the form of a catalog, a series of postcards, a notebook with sell sheets—whatever is the best way to introduce your product and to plan for future additions to the line. Unless buyers are familiar with you or your line, color is a plus and photographs help.

Packaging

It's important to distinguish here between retail packaging and packaging for shipping. Both have the opportunity to help promote the product. As far as retail product packaging is concerned, the investment should directly correlate to the package's potential to add value to the product. Conversely, if the product is to be shipped directly to

the consumer, the shipping container is an opportunity for a promotional message.

In-store merchandising

Retail displays may or may not be necessary to help gain retail shelf or floor space. It depends on the product. With some products, the need to display merchandise is critical. If a display is required to help sell your product, the cost of the merchandising materials may be bundled with a minimum order of product and priced accordingly.

COST-EFFICIENT EXPOSURE

As a product marketer, your world is governed by margins, the gross profit of your product. The less you spend, the higher your profit. This being the case, personal selling and publicity will be two of your primary marketing tools.

Personal selling

Because you're new at this, you'll want to quickly establish credibility and a presence. Try personal selling. Meet with potential buyers. Meet with retailers. Key trade shows are cost-efficient.

Trade shows

You will want to find out the shows that are key to the markets you're after. Designers who are looking to get shelf space in specialty stores of one kind or another have utilized trade shows to introduce new product lines. They're also a good way to maintain contact with other product designers, manufacturers and buyers.

Before you commit to space at a show, attend the show to find out if it's worth the investment. If timing or cost doesn't make that possible, make contact with show management. They probably won't release a list of attendees but you can ask questions like "Will so-and-so be there?" For more information on trade shows that might be helpful to you, see "Trade Shows" in chapter twelve.

On cultivating sales reps: I don't spend enough time with that side of the business. My approach is rather organic/haphazard. If a good opportunity comes to me I tend to trust it more than if I seek it out and hunt it down.

— Jane Timberlake
A-1 Product Co.

PREMIERE TRADE SHOWS
FOR NICHE PRODUCTS

The New York International Gift Fair and the San Francisco International Gift Fair are the two leading shows for gifts and decorative accessories in the U.S. If you can choose only one, opt for New York; it fills more than one-half million square feet. Both take place twice a year; usually in February and August. Sections can include General Gifts, Tabletop and Homeware, Decorative Accessories, Personal Accessories, Accent on Design®, Just Kidstuff®, The Museum Source®, New and Distinctive Resources, Floral and Garden Accessories, and Handmade. Attendees are from specialty and department stores, gift shops, jewelry stores, interior designers, importers and distributors of home products, mail order catalog companies, museums and galleries, stationery stores, gourmet shops, juvenile stores, crafts retailers.

Accent on Design is the section that many designers aspire to. It is juried and there's a waiting list to get in. All prospective product lines are reviewed by a committee who selects work based on creativity, originality and good design. The jury is comprised of industry professionals. If you are a single-product company, you probably shouldn't bother applying; and if you want a leg up, ask to see someone's entry submission to find out what kind of things interest the jury. Call the New York International Gift Fair to get an application for this section.

New York International Gift Fair
George Little Management, Inc.
Ten Bank St., Suite 1200
White Plains, NY 10606-1954
Phone: (914) 421-3200
Fax: (914) 948-6180

San Francisco International Gift Fair
Western Exhibitors, Inc.
2181 Greenwich St.
San Francisco, CA 94123-3493
Phone: (415) 346-6666
Fax: (415) 346-3493
To register for either show, call (272) 800-SHOW. (For additional trade show listings, see chapter twelve.)

PRESS KIT

When you launch your product to the market, you should have a press kit. It need not be fancy, but it should include the basic information that will make a writer's or editor's life easy. You will get calls and you should have this tool ready. The press kit should include:

- Product fact sheet
- Product photo (color slide)*
- Principal bio
- Principal photo (optional)
- Design statement (why the product was created; what inspired its development; why particular materials were selected and what makes them unique)
- Catalog (if one exists)
- How someone can reach you for more information

*If the product usage is not readily understood, show the product in use.

Sales reps

There are a number of manufacturer's rep associations and listings you can contact. Designers Giovanni Pellone and Bridget Means say they've tried rep associations but with little success. The trick, Pellone says, is not just to find a rep, but to find the right one in terms of image and sales channels. Pellone offers this advice to help source the best reps:

- Talk to potential reps or manufacturers at trade shows, etc.

- Talk to buyers you've established a good relationship with and ask them where they get their best products.

- Contact manufacturers with related, but not conflicting products and find out who reps them in a certain territory.

- Check out gift and merchandise marts.

Publicity

A placement in *InStyle* resulted in dozens of inquiries to Zolo Inc. for a new home accessories line. Public relations can be pivotal to the success of a new line and is one of the most affordable tools you can utilize. You may be tempted to hire a PR consultancy to help you initially, but you might want to try it yourself until you can afford outside counsel. Here's what to do.

- Make a list of publications and media outlets that you think will be interested in your product. Read the publications before you proceed to be sure your product is appropriate for that publication. If you need help assembling a list of publications, get a copy of *Bacon's* (for more information, see "Directories" in chapter twelve).

- Next, figure out the right person to contact within a single organization. The general rule of thumb is never to send a release to more than one person at a single venue. To identify the best

editors/writers at a given publication, start with the new products editor. If you don't know who it is, call the publication and find out.

- Then, write a brief news release. Connecticut-based PR expert Mary Ann Dostaler says to keep the writing tight, apply the "cocktail party" test. "Imagine you are at a cocktail party and need to describe your product to a guest. Since there are a lot of things going on in the background, the guest's attention can be easily diverted." She says her point is that what you say has to be brief, to the point and captivating.

- Include a photo of the product. Attach to the photo the name of the product, firm name, phone number and a brief description. Also include a personal design statement. This is important if your product is art-, design- or architecture-oriented.

- If the product requires show-and-tell to get the audience to really understand or appreciate it, contact new product editors for a face-to-face meeting.

- If your product is truly unique, your approach might be altered. Look at your list of media outlets and prioritize them. Approach the most important one first. "If they take it, great," says Dostaler. "If not, go on to the next one on your list. Don't get discouraged if no one wants to pick up the story. Just keep trying."

- You can also post your release on your Web site. You can utilize a newswire service or other organizations that offer this service for distribution. For instance, www.webthemes.com will post your Web site to search engines and send news releases.

Create word-of-mouth advertising

Word-of-mouth advertising is the best advertising you can get. It's free and it's credible. You can create a groundswell of interest by carefully selecting a few key people to preview your product.

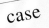
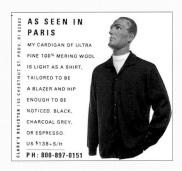

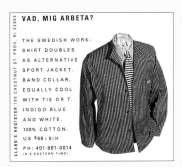

Clark's Register became official when the company ran a small-space, black-and-white ad in the *New Yorker*. Fortunately for principal John Clark, he was able to find a medium that would help him cost-efficiently reach a very specific audience, male, highly educated and affluent.

The first ad featured a wool merino sweater from Paris that since has become "basic stock," a staple product that is in constant demand, for Clark's Register. At the time, it was his one and only product. Clark had been advised by experts in mail order not to hold the goods until he started getting orders. The idea was that in the ad he would say six to eight weeks for delivery, wait four weeks, see how many orders he had and then place the order.

The first week the ad ran, the week after Thanksgiving, Clark received just one call. "I was a little nervous," he said. Because it was the holiday season, he went ahead and placed his order with his supplier. The next week, Clark's Register was swamped. By the end of the holiday season, they had fulfilled their orders, with some last-minute reorders and the benefit of air express overnight delivery for fill-ins, and finally broke even. "I didn't have a single piece of goods left in inventory and I'd fulfilled all my orders so I thought I was a pretty smart mail-order marketer," he says. His first selling season ended on an up.

Over the next months he traveled, looking for items that would round out his product line. A Swedish workshirt and a key ring from Finland were among his selections. Clark's thought was to create a mail-order catalog. By the fall, he had an idea of what his offering would include and figured, "I've got a line." He scrambled and produced a tiny catalog. He put his ad back in the *New Yorker* and this time he'd added tiny, 4-point type that said "Send for a free catalog." They received 700 responses for the catalog which were converted into 150-200 orders. Clark's Register went on to produce an entire series of ads, shown here.

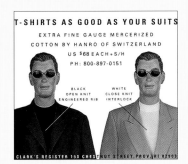

Sometimes you're lucky

Magnetic Poetry is on Jerry Seinfeld's refrigerator door. It's been on TV shows *Beverly Hills 90210, Caroline in the City* and on the real-life refrigerators of Darryl Hannah, Tim Robbins, Michael Stipe and Robin Williams. A Pop Pillow from Zolo Inc. adorns the couch on the set of *Friends* (look for the sitar). Canyon Design's Jill Harris developed a wristwatch called the Biological Clock. It was first sent as a thank-you gift to a fertility specialist. He spread the word among his peers, and Harris began to receive orders from fertility clinics around the country. Her news release was picked up by Associated Press, which led to dozens of radio interviews and hundreds of sales.

Advertising

Advertising is expensive for a start-up but it's one of the most efficient ways to reach a large group of people. Nevertheless, if you have a niche product, you also have a limited audience to reach. Unless you can target your customer efficiently, or have another goal such as reaching a particular buyer segment or using it as a primary vehicle for a direct-response program, skip advertising for now.

Other tools

There are other promotional tools to help launch your product. The most creative and compelling promotions will dramatize the unique nature of your product. Consider dimensional mailings to key buyers or special promotions that give retailers unique ideas to help sell-through your product (e.g., seasonal displays).

CONSIDERATIONS FOR DIRECT RESPONSE

So, you've decided to forget the potential hassles of retail and want to market to consumers directly. Althought we don't take an in-depth look at this area, here are a few considerations:

- Mail order is all about prospecting. And in order to prospect, you

MARKETING YOUR PRODUCT ON THE WEB

As the quality of the World Wide Web increases, so too will the quality of participants. Jane Timberlake admits she hasn't had much luck on the Web. "I'm sure of its functionality but it hasn't benefited me directly yet."

To explore the sales potential in Web site sales, visit www.e-land.com/. It offers statistics on the demographics of Net users.

If you want to find out more about how E-mail advertising works, try www.postmasterdirect.com

If you want more information in general, try NetRevenue, a webzine that aspires to help businesses make their Web sites more profitable. To access: emailex.com/netrevenue/

Also try Guerrilla Marketing Online. To access: www.gmarketing.com

PRODUCT DESIGNERS ON THE WEB

If you want to see how a few of the designers featured in this book have presented themselves and their products on the Web:

www.a-1product.com

www.clarksregister.com

www.dgi.net/tilka

www.metalstudio.com

www.walkingman.com

need to mail to people who are already mail-order customers. According to John Clark, "that's the biggest dividing line out there." Finding the right list has less to do with demographics and psychographics, "you have to find mail-order customers, people who are willing to purchase through the mail."

- The quality of the list you buy is the single most important factor in your success. One of the best starting places for general consumer lists is Donnelly Marketing. They now have a Web site that's available on-line. At the site, you can purchase consumer mailing lists with five hundred to fifty thousand names. You can choose records (names) demographically and/or geographically. You can also generate, preview and format your list on-line and they'll send mailing labels to you. To access: www.liststore.com

- Direct-response advertising can be effective—and cost-efficient—if you do your homework. Many publications offer readership studies that can provide valuable insights into buying patterns and usage habits. The use of a toll-free number in your ad will significantly increase your response rates.

ONE FINAL THOUGHT

When you launch your product, you are in the driver's seat. Your marketing tools have the power to shape how buyers and customers think of you and your product.

- Talk about why certain materials were selected.

- Highlight why colorations may vary.

- Tell customers how they should care for your product.

- Tell customers how or where the product was made.

This will help both buyers and customers to understand your product.

CHAPTER 11

what's

What do you do after you've successfully designed, manufactured and launched a new product line? "Once you achieve a certain degree of success in the market, you must continually add new items and expand your line to maintain your clientele's interest and loyalty," say Zolo Inc. partners Sandra Higashi and Byron Glaser.

So the answer is: start the process all over again. Single-product companies rarely make it over the long haul. And that's one of the biggest surprises for designers and others who have had initial product success. For example, the average life span of a product in the giftware business is two years—if you're lucky.

next?

During the next buying cycle after your first season out there, buyers will pester you with questions like, "What's new?" and "What do you have that's different?" If you don't have something new, they're likely to look someplace else. To be forewarned is to be forearmed. If you want to sustain a product design business, you have to continually design new products.

PRODUCT HYBRIDS

You can anticipate the need for new products early in the product design stage. Think about how you can hybridize the product you've already designed. What offspring or variety can you make from what you've already created with little to no additional investment?

Benza transformed ZAGO, the folding cardboard trash can (see chapter two) into a "line" by offering a variety of graphic options. The initial line includes nine graphic treatments, but, by making the product available in three different sizes, Benza created a new offering. What's more, each of three visual groupings are given a name and presented separately.

I think of my product design business as an adult lemonade stand. I get the same wave of excitement each time I sell a product that I did when I sold a glass of lemonade. They like it! They're coming back for more.
— Jill Harris
Canyon Design

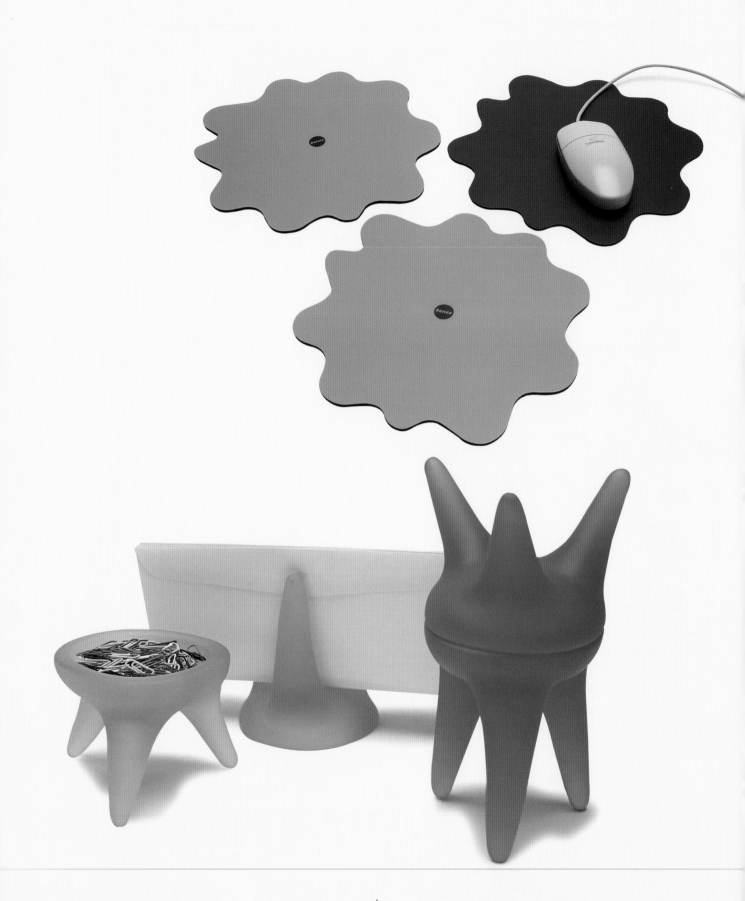

Benza isn't relying on the sales of ZAGO to sustain the growth of its business. In fact, the company has an aggressive product-development strategy in place that goes at least three years out. Founder Giovanni Pellone says his approach is simple, "It makes a lot of sense to create products that relate to previous ones you've done."

One way to develop new products that connect to their predecessors is to employ similar materials and like manufacturing processes. The idea is that because you've already developed a particular expertise working with certain materials and toolings, product development will take less time and manufacturing costs will ostensibly be lower. Products might also connect visually. Designs created by the same hand and heart often share a certain look and like-mindedness. Still another option is to consider the intended context of the product (where it is designed to be used) or application (how it is to be used). In the case of Benza, new product initiatives will continue to combine at least two of three strategies noted above.

The mission of Benza is to develop unique products for the home office environment. The goal is to enable consumers to decorate their home office—with Benza products—for less than $100. As the line develops, each product addition is intended to work with its precedents; or, stated another way, each new Benza product is a harbinger of what's to come. It is not surprising that Benza has, as *New York* magazine noted in Best Bets, "broken the mouse pad canon" with its Squiggle mouse pads. Made of Lexan, with a nonskid rubber backing, they are described as "virtual paint splatters" which will "liven up the most antiseptic computer workplace." Benza has also started to reinvent desk accessories altogether. The *New York Times* called a new line of Benza holders "colorful creatures from another desktop planet." The Urchin container opens up for paper clips, while its top holds envelopes and papers. What's more unusual than the Urchin's look is the strategy behind it. It was designed by Roberto Zanon, a young Italian architect and designer who lives in Padua and teaches at the Venice University's School of Architecture.

The integration of non-Benza designers is not just whim. Pellone and partner, Bridget Means, believe other designer names add credibility to their line. Outside talent also means more resources, enabling them to produce more products with shorter development times and at less cost. And it provides designers—particularly those who might not have the tenacity or desire to start their own product design company—with a ready-to-go marketing and manufacturing resource. Future product initiatives include items that are relevant to the home office market with potential to cross over into other areas of the home as well, such as a desk lamp suitable for a variety of environments.

Why is it important to have a product line? First, it helps to garner better exposure in retail environments. As Benza grows its line, retailers now have enough product to create a "Benza corner." Not only does it enhance merchandisability, related products naturally help cross-sell one another. Finally, and perhaps most importantly, a full line will help to develop a stronger, sustainable brand name in the minds of buyers and consumers.

From Zolo to Zoop, Zolo Inc. has designed, produced and marketed an average of two new products per year since the company's initial foray into product design. Though each product is completely different, the line retains the spirit of its creators, Sandra Higashi and Byron Glaser, in each new product they roll out. Taken from their product catalog, this is a visual essay of how their company has grown.

1986

1992

Zolo – wood

Kooky Cutters

1993

ZZZ

Applied Chemistry

1994

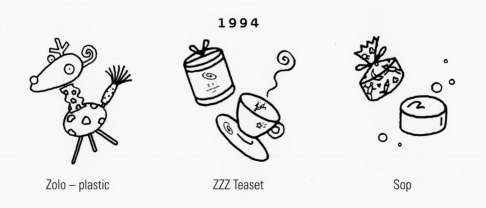

Zolo – plastic

ZZZ Teaset

Sop

1995

Dirty Clean Tough

Expressionizm

1996

Mod Pop Pillow

Pod Pop Pillow

Log Pop Pillow

Oblique Pop Pillow

Bean Pop Pillow

Sitar Pop Pillow

Splat Coaster

Q Cards

mmm

1997

Motorized Zolo

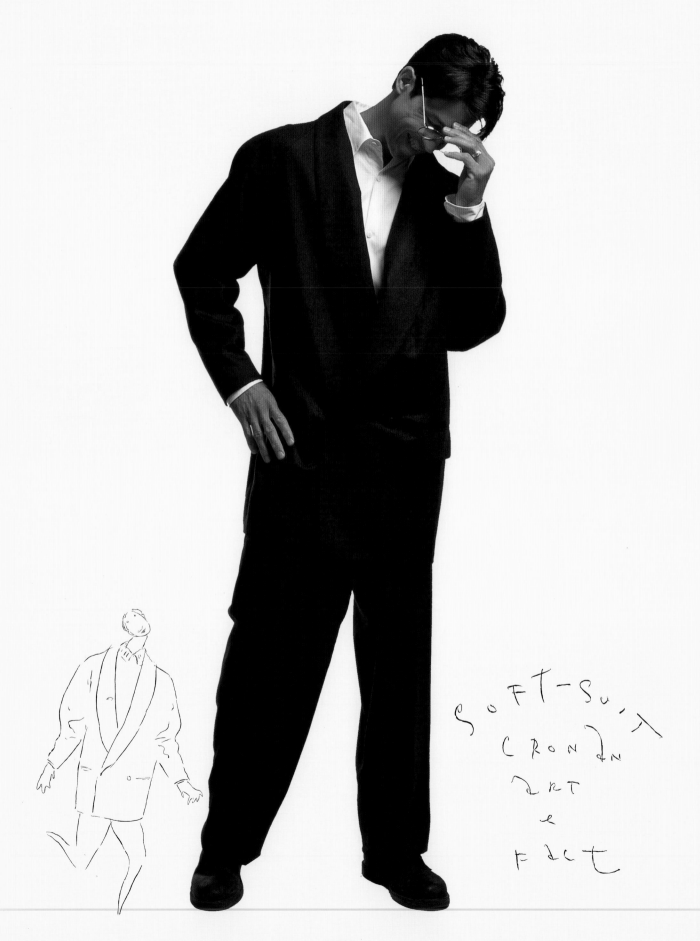

SOFT-SUIT
CRONIN
ART
e
FACT

WHEN WAS THE LAST TIME YOU GOT A VALENTINE FROM A COMPANY?

The majority of Walking Man's customers are men. A week and a half before Valentine's Day, Walking Man customers received a mailing which included a valentine they could give to a significant other—with or without a gift from Walking Man.

Housed in a simple glassine envelope with a lovely sentiment taken from the work of Thomas Lovel Beddoes, the gesture worked on several levels. First, it was a gentle reminder. "I would have liked to have timed it so that it was received the day before the holiday," says president Karin Hibma, "but I didn't want to push it." Next, the mailer reinforced the positioning of the Walking Man brand as "thoughtful" and "helpful," watchwords for how Hibma has carefully built the brand from day one. Finally, admits Hibma, "the valentine, in reality, was an invitation to buy one of our special crimson origami jackets."

Whatever it was, it worked. Hibma calls her approach to direct mail "correspondence marketing." And now that the Walking Man brand is well-known with a loyal following, Hibma is turning single product purchasers into lifetime buyers. This is through unparalleled customer service and quality product. But it's also through thoughtful direct mail pieces that anticipate the needs of customers. "We are trying to evolve with our customers and to be a resource they can count on," says Hibma. This is an understatement. Walking Man has a cult-like following. They know what their customers want and they give it to them on a silver platter.

For instance, the introduction of the "Soft Suit" challenged a whole new way of thinking about dressing. No two people look the same in it and "we didn't want to superimpose on someone's imagination," says Hibma. How then, do you promote a product when you're not able to show how someone might look in it? San Francisco talent Ward Schumaker was asked to interpret how one feels when they wear the garment. The result was a series of extraordinary, attitudinal interpretations that are "powerful, sexy, slim and comfortable," says Hibma.

Hibma and vice president Mary Coe then audited Walking Man's customer base and handpicked people they thought would be interested in the innovative wool ensemble. A direct mail postcard with a swatch of fabric ("our way to let customers 'pat the bunny,'" she says) went to a small percent of Walking Man customers. Because the garment was priced like a suit, a special payment plan was offered. The response rate? "Something like 60-70%," says Hibma.

Now, after seven years with Hibma at the helm, Walking Man is just beginning to hit its stride.

When Benza introduced ZAGO, it essentially had a single product. But buyers saw a full product line with twenty-seven stock-keeping units (SKUs) to choose from. With a hybrid product strategy, a single-product company can position itself as a full-line supplier.

NURTURE FOR GROWTH

While it's important to think about new products, it's also important to tend to your existing product or product line to maintain its momentum. It is possible to extend the average life span of a product. For instance, Zolo has been selling for ten years strong in a category that averages a lifetime of a couple of years. As such, you'll want to consider what kinds of marketing initiatives you should undertake while your product is in various stages of the product life cycle.

WHAT TO DO WHEN YOUR PRODUCT IS IN ITS GROWTH STAGE

When your product is on the upswing, you want to keep the growth curve going in the same direction. One way to do this is to tap new markets with the same product. That's what Sandra Higashi and Byron Glaser did with their award-winning Zolo. The original wooden toy set retailed for over $150—fine as an adult collectible but way too much for a parent to spend on a toy for a child. Created with hand-carved, hand-painted wooden parts, it was not possible to produce it at a lower cost. Instead, they redesigned the product in plastic, licensed it and Zoom! Sales are skyrocketing with the support of dedicated licensee, Wild Planet, a company that believes in the product as much as the principals of Zolo Inc.

It's a mission. The design is the simplest part. To make a product successful the most important ingredient is dedication. [You have to have] a dream—and a tolerance for sleep deprivation.

— Giovanni Pellone

Benza, inc.

STRATEGIES FOR EACH STAGE OF THE PRODUCT LIFE CYCLE

Growth Phase

Concentrate on creating awareness, preference and brand loyalty.

Introduce another new product or a hybrid of your existing product.

Differentiate your firm through nonproduct-related strategies to create top-of-mind awareness among buyers. Special programs for retailers, incentives for buyers, all these are viable considerations.

Turn your product offering into a full line.

Mature phase

Leverage your brand name to new but related products.

Reposition your product by considering alternate uses for it. For example, Benza's Urchin might be repositioned as a candy dish and sold to different venues.

Decline Phase

Recognize when it's time to phase out a product; go out on a high.

Keep raising the bar each time you achieve a new benchmark of success. Develop and sustain a work ethic—among those that work with you and for you—that places a premium on quality. Always originate products that meet a customer need or want; if you emphasize this over all else, success will come.

Someone once said that ideas won't keep...something must be done about them. As a designer, you are an originator, someone with intuition, creativity and vision. You are uniquely equipped with the potential to create something of value, something that may make the world a little better, or at least look and feel a little better. You have the resources to teach people to be attentive, to look at and to think about things in fresh ways. You have the power to sensitize a desensitized world. As you go forward, please show us what we can become. Enlighten us. Offer us vision. Make us dream. Give us your best stuff.

After you've heard it all, listen to your heart.

— *Sandra Higashi and*
Byron Glaser
Zolo Inc.

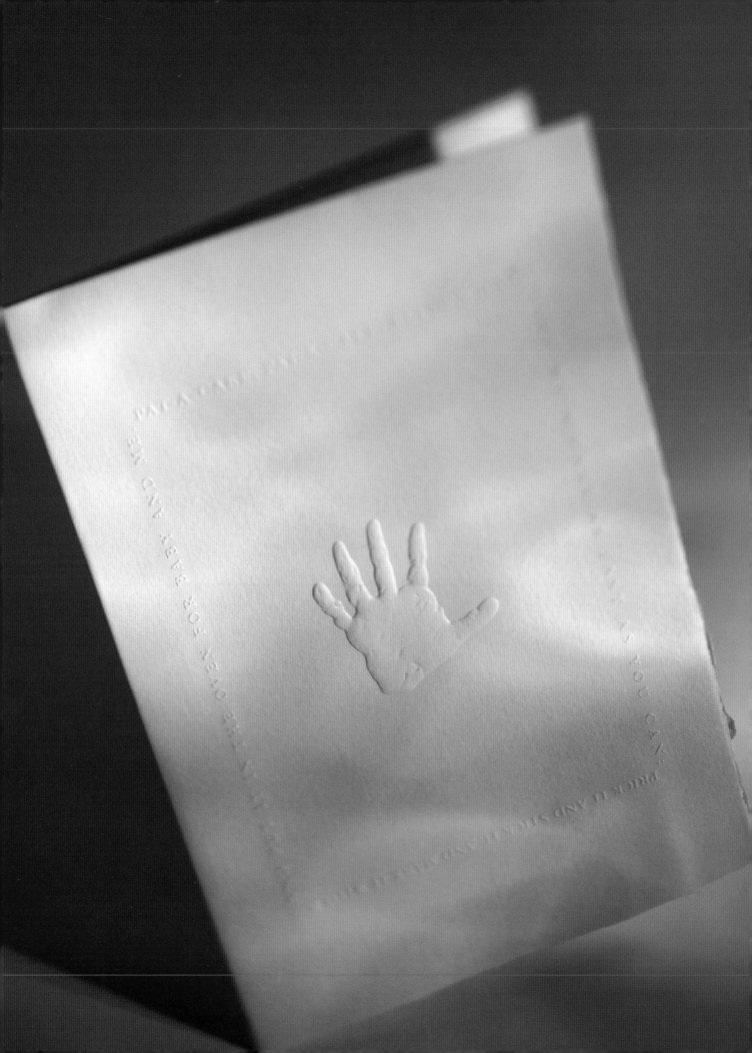

access

Want more in-depth information? In addition to the sources listed throughout the book, this section is intended to provide you with additional sources of information to consult during the design and development stages.

Associations/Design and Related

If you do not find the association you're looking for, check the *Encyclopedia of Associations* (see Directories in this chapter).

American Craft Council
72 Spring St.
New York, NY 10012-4019
Phone: (212) 274-0630
E-mail: amcraft@mindspring.com

American Institute of Graphic Designers
1059 Third Ave.
New York, NY 10021
Phone: (212) 807-1990

American Society of Furniture Designers
P.O. Box 2688
High Point, NC 27261
Phone: (910) 884-4074

Association of Chartered Industrial Designers
234 Bay St., Box 18
Toronto, ON M5K 1B2 Canada
Phone: (416) 216-2141
Fax: (416) 368-0684

Industrial Designers Society of America (IDSA)
1142-E Walker Rd.
Great Falls, VA 22066
Phone: (703) 759-0100
E-mail: idsa@erols.com
Web address: www.idsa.org

Society of Environmental Graphic Designers (SEGD)
1 Story St.
Cambridge, MA 02138
Phone: (617) 868-3381

Associations/Industry Related

American Furniture Manufacturers Association (AFMA)
Box HP-7
High Point, NC 27261
Phone: (910) 884-5000
Web address: www.afmahp.org

Color Marketing Group
5904 Richmond Highway, Suite 408
Alexandria, VA 22303
Fax: (703) 329-0155
Web address: www.colormarketing.org

Greeting Card Association
1200 G St. NW, Suite 760
Washington, DC 20005
Phone: (202) 393-1778
Fax: (202) 393-0336
Web address: www.greetingcard.org

Home Fashions Products Association
355 Lexington Ave.
New York, NY 10017-6603
Phone: (212) 661-4261

Human Factors & Ergonomics Society
P.O. Box 1369
Santa Monica, CA 90406-1369
Phone: (310) 394-1811
E-mail: hfes@compuserve.com
Web address: http://hfes.org

Institute of Packaging Professionals (IoPP)
481 Carlisle Dr.
Herndon, VA 20170
Phone: (703) 318-8970
E-mail: info@pkgmatters.com
Web address: www.packinfo-world.org

Institute of Store Planners
25 N. Broadway
Tarrytown, NY 10591
Phone: (914) 332-1806
Web address: www.isp.org

International Interior Design Association (IIDA)
341 Merchandise Mart
Chicago, IL 60654
Phone: (312) 467-1950
E-mail: iidahq@aol.com
Web address: www.iida.com

Licensing Industry Merchandiser's Association
350 Fifth Ave., Suite 2309
New York, NY 10118
Phone: (212) 244-1944
Web address: www.licensing.org

National Tabletop Association
355 Lexington Ave.
New York, NY 10017
Phone: (212) 661-4261

Package Design Council (PDC)
481 Carlisle Dr.
Herndon, VA 20170
Phone: (703) 318-7225
E-mail: pdc@pkgmatters.com

Toy Manufacturers of America, Inc.
The Toy Building
200 Fifth Ave., Suite 740
New York, NY 10010
Phone: (212) 675-1141
Fax: (212) 645-3246

Associations/Materials

American Hardware Manufacturers Association
801 N. Plaza Dr.
Schaumburg, IL 60173
Phone: (847) 605-1025
E-mail: ahma@ahma.org
Web address: www.ahma.org

American Printed Fabrics Council
104 W. 40th St., 18th Floor
New York, NY 10018
Phone: (212) 869-7880

American Textile Manufacturers Institute
1130 Connecticut Ave. NW, Suite 1200
Washington, DC 20036
Phone: (202) 862-0500
Web address: www.atmi.org

Fine Hardwood Veneer Association
260 S. First St., Suite 2
Zionsville, IN 46077
Phone: (317) 873-8780
E-mail: fhuaawmawc@compuserve.com

Glass Packaging Institute
1627 K St. NW, #800
Washington, DC 20006
Phone: (202) 887-4850
Web address: www.gpi.org

Hardwood Manufacturers Association
400 Penn Center Blvd., #530
Pittsburgh, PA 15235
Phone: (412) 829-0770
E-mail: info@hardwood.org
Web address: www.hardwood.org

Society of the Plastics Industry
1801 K St. NW, Suite 600K
Washington, DC 20006
Phone: (202) 974-5200

Business Information (General)

In addition to the sources listed throughout the book:

Business Information Sources
Lorna M. Daniells. Berkeley: University of California Press, 1997. Written by a business bibliographer for consultants, information analysts, etc., this is an excellent resource to practically any business-related topic.

Fast Company
Fast Company is a magazine that is defining the new world of business and capturing the spirit of the people who are making it happen.
Phone: 1-800-688-1545
Web address: www.fastcompany.com

For AOL Users:
America Online users are encouraged to participate in on-line chats. Start with keyword "Your Business" and this will take you to dozens of individual areas covering all types of businesses.
Web address: www.aol.com

Home Office Association of America
Offers information for the entrepreneur including reference materials and many links.
Web address: www.hoaa.com

Inc.
A magazine for small, growing businesses. Also available on-line.
Web address: www.inc.com

Small Business Administration
Now available on-line.
Web address: www.sbaonline.sba.gov.

smallbizNet
Created with the intent to assist entrepreneurs and small business, this site offers much information of a general nature on topics ranging from associations to industry-specific information to purchasing and supplier relations.
Web address: www.lowe.org.

U.S. Census Bureau
Social, demographic and economic information.
Web address: www.census/gov.

Buyers

In addition to sources listed throughout the book:

Access Business Online
Brings buyers and sellers together.
Web address: www.clickit.com

Copyright/Trademarks, etc.

U.S. Copyright Office
For general information, call or write:
Copyright Office
Publications Office
Library of Congress
Washington, DC 20559
Phone: (202) 707-3000
To order copyright forms:
(202) 707-9100
Web address: www.loc.gov/copyright/
E-mail: copyinfo@loc.gov.

The Copyright Clearance Center, the American Society of Media Photographers, the Graphic Artists Guild, and the National Writers Guild are developing an on-line system to manage licensing, permissions and royalties.
Phone: (508) 750-8400
Web address: www.copyright.com.

Design Centers

Nearly every large city has a design center (to-the-trade showrooms for furnishings, fabrics, etc.). To enter most design centers, you need to be accompanied by someone in the trade. If you don't know an interior designer, check the Yellow Pages or contact the International Interior Design Association (IIDA) (see "Associations/Industry Related" in this chapter).

Directories

In addition to the sources listed in individual chapters:

Bacon's Directories
(Useful for publicity purposes)
Bacon's Information Inc.
332 S. Michigan Ave.
Chicago, IL 60604
Phone: (312) 922-2400

Business Buyer's Guide
(Toll Free National 800 Directory from AT&T)
Organized by category.
Phone: (800) 562-2255.
Web address: www.tollfree.dir.att.net

Encyclopedia of Associations
Gale Research Inc.
835 Penobscot Bldg.
Detroit, MI 48226-4094
Phone: (313) 961-2242
Web address: www.thomson.com/gale.html

Gale Directory of Publications
Gale Research, Inc.
835 Penobscot Bldg.
Detroit, MI 48226-4094
Phone: (313) 961-2242
Web address: www.thomson.com/gale.html

Gift & Decorative Accessory Buyers Directory
Gayer-McAllister Publications
51 Madison Ave.
New York, NY 10010
Phone: (212) 689-4411

O'Dwyer's Directory of Public Relations Firms
J.R. O'Dwyer Co., Inc.
271 Madison Ave.
New York, NY 10016
Phone: (212) 679-2471
E-mail: jackodwyer@aol.com

Standard Rate and Data Service (SRDS)
3004 Glenview Rd.
Wilmette, IL 60901
Phone: (800) 323-4601

Sweet's Catalog File
McGraw Hill
1221 Ave. of the Americas, 20th Floor
New York, NY 10020
Phone: (212) 512-6567
Fax: (212) 512-2348

Thomas Register of American Manufacturers (for sourcing)
Thomas Publishing Company
5 Penn Plaza
New York, NY 10001
Phone: (212) 695-0500
Web address: www.thomasregister.com or www.thomaspublishing.com

Export

Export Hotline & TradeBank
Provides current market data for about 50 industries in 80 countries as well as a global directory of business listings.
Fax: (617) 292-7788
Web address: www.exporthotline.com

Trade Information Center, U.S. Department of Commerce
Provides advice for small- to medium-sized companies that are new to export. Offers special programs at U.S. embassies around the world to organize interviews with the kinds of companies you want to meet.
Phone: (800) USA-TRADE
Fax: (202) 482-4473
Web address: www.itadoc.gov.tic

Financing

In addition to the sources mentioned in chapter eight:

The National Association of Small Business Investment Companies Membership Directory
Lists about 70% of active Small Business Investment Companies (SBICs).
Phone: (202) 628-5055

Price Waterhouse
One of the Big Six accounting firms does a quarterly survey on lending activity from venture capital firms. You can also get a sizable list of Web-venture capital firms.
Web address: www.pw.com/vc

Small Business Administration's Directory of SBICs
Lists a variety of information on preferred industries and investment policy. Free copies available through your local SBA office.
Phone: (202) 205-7589
Web address: www.sba.gov

Industrial Design

See Product Design in this chapter. Also, there are a number of trade publications for industrial designers, mostly for engineers and Original Equipment Manufacturers (OEMs). If you're interested, look them up in *Standard Rate and Data Service* (see "Directories" in this chapter).

Licensing

International Licensing Show
A leading trade show for licensors and licensees. Presently managed by Expocon.
Phone: (203) 256-4700
E-mail: info@expocon.com
Web address: www.expocon.com

Licensing Industry Merchandisers' Association
The leading trade organization. Publishes a magazine called the *Licensing Book*. Available to nonmembers if you qualify.
Phone: (212) 244-1944
Web address: www.licensing.org

The Licensing Business Handbook
Karen Raugast. Brooklyn, New York: EPM Communications, Inc., 1995. Good book on how the licensing business works. Explains money issues, contract basics and a lot more.

The Licensing Letter
A newsletter on the licensing business (who's doing what with whom). Order a back issue or two to determine if it will be helpful to you.
EPM Communications, Inc.
160 Mercer St., 3rd Floor
New York, NY 10012-3212
Phone: (212) 941-0099
Fax: (212) 941-1622

Licensing Resource Directory
A who's who, organized by property, company and licensing category. Created by Licensing Industry Merchandiser's Association (LIMA) and Expocon Management Associates, Inc.
Phone: (203) 256-4700

Manufacturing

Manufacturers Information Net Home Page
Information source for manufacturers.
Web address: www.mfg.info.com

Marketing

The Marketing Imagination
Theodore Levitt. New York: Free Press, 1986. By the editor of the *Harvard Business Review,* the content is sharp and thought-provoking.

Positioning
Al Ries and Jack Trout. New York: McGraw-Hill, 1986. This is but one of several good books (*Marketing Warfare, Bottom-up Marketing*) by the same authors. They prove that how a product is perceived by the consumer is central to brand success.

Materials

In addition to resources listed in chapter six and Directories in this chapter, look in *Standard Rate and Data Service (SRDS)* for publications listed under specific materials you're interested in. To find *SRDS,* see "Directories" in this chapter.

Design Info
An engineering catalog (on-line). Links engineers to products.
Web address: www.atypi.org

ISdesigNET
On-line version of *Interiors & Sources* magazine.
Web address: www.isdesignet.com

Craft Schools
Consider taking an intensive or a course that focuses on a particular material. Craft schools such as Penland/North Carolina [(704) 765-2359] and Haystack/Maine [(207) 348-2306] offer instruction in such areas as iron, metals, surface, glass, clay and wood. Call for information.

Trade Associations
If you're looking for resources on substrates/materials such as glass, metal, paper, plastics or wood, start with "Associations/Materials" listed in this chapter.

Other Sources

American Craft Magazine
Published by the American Craft Council.
Phone: (800) 562-1973

Great Design Using Non-Traditional Materials
Sheree Clark and Wendy Lyons. Cincinnati: North Light Books, 1996. Includes tips on working with materials such as metal, glass, textiles, wood, chipboard, corrugated cardboard. Does not include specific sources of supply.

The I.D. Design Sourcebook
A good resource to specific suppliers of materials. Call to find out how to obtain a copy or to subscribe.
Phone: (212) 447-1400
Web address: www.idonline.com/sourcebook
E-mail: IDMag@aol.com

Metropolis
Classified ads often include specialty services such as metalwork, surface decoration, etc.
Phone: (800) 344-3046
Web address: www.metropolismag.com

Merchandise Marts

"Marts" are showrooms that are set up in major cities for buyers. Check out the requirements before you go. Some major markets are listed below.

Atlanta Merchandising Mart
240 Peachtree St., NW, Suite 2200
Atlanta, GA 30303
Phone: (404) 220-3000

Dallas Trade Mart
2100 Stemmons Freeway
P.O. Box 420207
Dallas, TX 75342
Phone: (800) 325-6587

International Showcase
225 Fifth Ave.
New York, NY 10010
Phone: (212) 684-3200
Fax: (212) 686-9514

Los Angeles Merchandise Mart
1933 S. Broadway, Suite 244
Los Angeles, CA 90007
Phone: (213) 749-7911

The Merchandise Mart
200 World Trade Center
Chicago, IL 60654
Phone: (312) 527-4141
Web Address: www.mmart.com

Additional gift and buying centers are identified in *Giftware News,* a monthly publication for the giftware industry.

Modelmaking/Prototyping

The I.D. Design Sourcebook
A good resource for modelmaking and prototyping services nationwide.
Phone: (212) 447-1400
Web address: www.idonline.com/sourcebook
E-mail: IDMag@aol.com

Professional Modelmaking
Norman Trudeau. New York: Whitney Library of Design, 1995. This is a handbook of techniques and materials for modelmaking.

Pricing & Distribution

Handbook of Pricing & Ethical Guidelines
Published by the Graphic Artists Guild.
Phone: (212) 791-3400
Also available from North Light Books, Cincinnati, Ohio.
Phone: (800) 289-0963

Product Design

HISTORICAL

George Nelson on Design
George Nelson. New York: Whitney Library of Design, 1979. Though out of print, this book shows the practical experience of an industrial designer and architect relative to issues facing designers in general.

Henry Dreyfuss, Industrial Designer
Russell Flinchum. This book was published in conjunction with a major exhibition of Dreyfuss's work at the Cooper-Hewitt, National Design Museum, Smithsonian Institution, New York.

Industrial Design, Reflection of a Century
Paris: Flammarion, 1993. Distributed by Abbeville Publishing Group, New York. Insightful texts, great visuals and an invaluable reference that spans over one hundred years of industrial design.

CONTEMPORARY

Communication Arts
Phone: (800) 258-9111
E-mail: subscription@commarts.com
Web address: www.commarts.com

Core Industrial Design Network
Regular reviews of "remarkable products" called "Contraption" edited by Allan Chochinov. Good resource info. Can also download a sample confidentiality agreement.
Web address: www.core77.com

The Design of Everyday Things
Donald A. Norman. New York: Doubleday, 1990. This book (also titled *The Psychology of Everyday Things*) reveals how smart design works and how it can jump-start business.

DesignOnline

Good source for general design information and links.
Web address: www.dol.com

I.D. Magazine
Be sure to check out the annual design review and the annual *I.D. Design Sourcebook.*
Phone: (212) 447-1400
E-mail: idmag@aol.com
Web address: www.idonline.com

Idea Cafe
Small business channel that helps to generate (what else?) ideas. Good links. Also includes accounting, tax, financing and legal information.
Web address: www.ideacafe.com

Industrial Design Workshop, The Creative Process Behind Product Design
Tokyo: Meisei Publications, 1993. Two volumes available, but the most recent is already out of print. Shows more than fifty case studies including auto, optical, precision and communication equipment.

The Inventor's Desktop Companion
Richard C. Levy. Detroit: Visible Ink Press, 1995. A professional inventor/marketer with more than ninety licensed products under his belt.

Metropolis Magazine
Phone: (800) 344-3046
Web address: www.metropolismag.com

Product by Design
Martin Pedersen, Graphis Press. International collection of product design. For free catalog write:
Graphis
141 Lexington Ave.
New York, NY 10157-0236

Vava
On-line, object-oriented design store with works from designers such as Takashi Kato, Etazoo Milano, Kozo Santo, Eric Chan and Daniel T. Ebihara. Products range from vases to letter openers to fun and functional inflatables.
Web address: www.vava.com.

Research
In addition to the sources listed in chapter three:

Find it Fast
Robert I. Berkman. New York: HarperPerennial, 1997. Lists dozens of information sources. Especially valuable for good tips and advice on how to find and use the experts behind the sources.

The Information Catalog
A free publication published bimonthly by FIND/SVP. Lists many industry, market and company studies available for purchase.
Phone: (800) 346-3787

The Practical Handbook and Guide to Focus Group Research
Thomas L. Greenbaum. Lexington, Massachusetts: Lexington Books, 1988. This is a thoughtful and comprehensive resource on focus group research: how to do it and how to use it.

Retail Stores

MUSEUM STORES
A partial listing of museum stores nationwide that are responsive to the kinds of niche products featured here and who have represented the work of many designers in this book.

The Guggenheim Museum Stores
1071 Fifth Ave. at 89th
New York, NY 10128-0112
Phone: (212) 423-3500

The Guggenheim Museum Stores—Soho
575 Broadway
New York, NY 10012
Phone: (212) 423-3875

Los Angeles County Museum of Art
5905 Wilshire Blvd.
Los Angeles, CA 90036
Phone: (213) 857-6151
Web address: www.lacma.org

The MoMA Design Store
11 W. 53rd St.
New York, NY 10019
Phone: (212) 708-9400

Museum of Contemporary Art (store)
220 E. Chicago Ave.
Chicago, IL 60611
Phone: (312) 397-4000
Fax: (312) 397-4098
Web address: www.mcachicago.org

Museum of Contemporary Art, Los Angeles (MOCA)
250 S. Grand Ave.
Los Angeles, CA 90012
Phone: (213) 621-1710

Philadelphia Museum of Art
26th/The Parkway
Philadelphia, PA 19130
Phone: (215) 684-7822

San Francisco MoMA
151 Third St.
San Francisco, CA 94103
Phone: (415) 357-4035
Web address: www.sfmoma.org

Whitney Museum Store/Store Next Door
943 Madison Ave.
New York, NY 10021
Phone: (212) 606-0200
Fax: (212) 472-1963

Museum Stores Association
501 S. Cherry St., Suite 460
Denver, CO 80222
Phone: (303) 329-6968
Fax: (303) 329-6134

CHIC GIFT AND SPECIALTY STORES AND BOUTIQUES
A partial list of stores you might want to check out if you're interested in venues that carry the type of products featured in this book.

Ad Hoc
410 W. Broadway
New York, NY 10012
Phone: (212) 925-2652
E-mail: adhocny@aol.com

Adesso
600 Central Ave.
Highland Park, IL 60035
Phone: (847) 433-8525

Alphabets (main office/warehouse)
121 Varick St.
New York, NY 10013
Phone: (212) 691-7447
Fax: (212) 691-7277

Chiasso
1332 N. Halsted
Chicago, IL 60622
Phone: (312) 397-0197;
(800) 654-3570 (catalog only)
Fax: (312) 397-0199

The Collector
2067 Merrick Rd.
Merrick, NY 11566
Phone: (516) 379-0805

Dom USA (CA)
1245A Third St. Promenade
Santa Monica, CA 90401
Phone: (310) 656-1122
Fax: (310) 656-0132

Dom USA (NY)
382 W. Broadway
New York, NY 10012
Phone: (212) 334-5580
Fax: (212) 334-5348

The Elements
752 Walker Rd.
Great Falls, VA 22066
Phone: (703) 759-0420
E-mail: elements@aerols.com

Felissimo
10 W. 56th St.
New York, NY 10019
Phone: (212) 247-5656
Fax: (212) 956-0816
Web address: www.felissimo.com

Fillamento
2185 Fillmore St.
San Francisco, CA 94115
Phone: (415) 931-2224
Fax: (415) 931-6304

The Gardener
1836 Fourth St.
Berkeley, CA 94710-1911
Phone: (510) 548-4545
Fax: (510) 548-4564

Kate's Paperie (Soho)
561 Broadway
New York, NY 10012
Phone: (212) 941-9816;
(800) 809-9880 (catalog only)
Fax: (212) 941-9560

F. kia (The Store)
558 Tremont St.
Boston, MA 02118
Phone: (617) 357-5553

Moss
146 Green St.
New York, NY 10012
Phone: (212) 226-2190
Fax: (212) 226-8473

MXYPLYZYK
125 Greenwich St.
New York, NY 10014
Phone: (212) 989-4300
Fax: (212) 989-0336

New York Public Library Store
Fifth Ave./42nd St.
New York, NY 10018
Phone: (212) 865-4515

Nuvo
3900 Cedar Springs Rd.
Dallas, TX 75219
Phone: (214) 522-6868
Fax: (214) 526-5551

October Studio
244 W. 19th St.
Houston, TX 77008
Phone: (713) 861-3411
Fax: (713) 861-7475

Whimsy
3234 N. Southport Ave.
Chicago, IL 60657-3227
Phone: (773) 665-1760

Zero Minus Plus/Fed Segal
500 Broadway
Santa Monica, CA 90401
Phone: (310) 395-5718
Fax: (310) 395-9829

Sales Representation
In addition to sources listed throughout the book:

RepLink
An on-line, matchmaking service for manufacturers, reps, wholesalers and distributors. Also offers resource listings.
Web address: www.replink.com

Sourcing
(See "Materials" in this chapter for additional information)

Graphic Designer's Sourcebook
Poppy Evans. Cincinnati: North Light Books, 1996. Includes more than 1,000 listings of suppliers of a variety of materials from patches and emblems to metal containers to glass medicine-dropper assemblies. The revised edition, entitled *Graphic Designer's Ultimate Resource Directory*, is due out in 1999.

Trademarks
See Copyrights/Trademarks.

Trending

Clicking
Faith Popcorn and Lys Marigold. New York: Harper Collins, 1996. The second book from the chairman of BrainReserve and the author of the best-selling *The Popcorn Report*. Identifies sixteen trends to the millennium.

Clicktime
A newsletter published by BrainReserve (see *Clicking*). To subscribe: BrainReserve, One Madison Avenue, New York, NY 10010. Accepts written inquiries only.

The Popcorn Report
Faith Popcorn. New York: HarperCollins, 1992. Offers hundreds of ideas on new products, new businesses, new markets.

The Yankelovich Monitor
Tracks consumer/lifestyle trends.
Phone: (203) 846-0100
Web address: www.yankelovich.com

Trade Shows

In addition to the premiere giftware shows featured on page 118, consider these venues to reach buyers.

	For what	Who attends
Boston Gift Show® 1-800-272-SHOW	Stationery, gourmet products and foods, toys, general gifts, floral items, decorative and personal accessories, tabletop products, traditional and contemporary crafts, souvenirs and jewelry.	Department and specialty stores, gift shops, mail order/catalog houses, boutiques, import/export firms, jewelers, craft and antique shops, florists and garden centers.
Chicago Gift Show® 1-800-272-SHOW	Giftware, stationery, tabletop products, games, floral items, gourmet products, home furnishings, toys, decorative and personal accessories, crafts, fashion accessories, jewelry and folk art.	Gift shops, department and specialty stores, mail order/catalog houses, distributors, boutiques, import/export firms, jewelers, craft and antique shops, florists and garden centers.
EX.TRACTS® 1-800-272-SHOW	Personal care products, aromatherapy products, body lotions, bath and shower gels, soaps, fragrances, candles, home fragrance products, bath accessories, small appliances and private label opportunities.	Specialty, chain department, gift and drug stores, mail order/catalog houses, home furnishing/decorative accessory retailers, bed/bath and linen stores, spas, wholesalers/distributors and more.
Gourmet Products Show® 1-800-272-SHOW	Cookware, tabletop products, gadgets, cutlery, specialty electric appliances, home textiles, garden and travel accessories, personal care products, specialty foods, coffee and teas.	Specialty and department stores, mail order/catalog companies, gift/gourmet shops, mass merchandisers, importers, distributors, and manufacturers' representatives.
ICFF® International Contemporary Furniture Fair 1-800-272-SHOW	Designers, manufacturers and representatives of contemporary furniture, lighting, floor coverings, wallcoverings, textiles and decorative accessories for the residential, home/office and contract markets.	Architects, residential and contract interior designers, retailers, store designers, facility managers, wholesalers and manufacturers.
National Stationery Show® 1-800-272-SHOW	Greeting cards, postcards, note paper, rubber stamps, picture frames, games, toys, calendars, party goods, desk accessories, writing instruments, small leather goods, prints and posters, balloons and more.	Department, chain and specialty stores; boutiques; stationery, card and gift shops; import/export firms; distributors; bookstores; bridal shops; party stores; hospital gift shops; garden centers and more.
The New York Home Textiles Show® 1-800-272-SHOW	Bed and bath fashions, table linens, kitchen textiles, decorative pillows, area rugs, window treatments and hardware, decorative accessories, personal care items, home fragrances, accent furniture and more.	Department, chain and specialty stores, mail order/catalog houses, home furnishing/decorative accessory retailers, interior designers, bed/bath and linen stores, wholesalers/distributors and more.
Surtex® 1-800-272-SHOW	Decorative fabrics, linens, apparel and contract textiles, wall and floor coverings, greeting cards, gift wrap, tabletop, ceramics and packaging.	Manufacturers from the home furnishings, domestics, apparel, contract, gift, greeting card and paper product industries; private label retailers and interior designers.
Washington Gift Show® 1-800-272-SHOW	Giftware, crafts, decorative and personal accessories, stationery, greeting cards, gourmet products and foods, floral and garden accessories, jewelry, books, furniture, tabletop products and more.	Specialty, chain, department and independent stores, gift and stationery shops, import/export firms, boutiques, mail order/catalog houses, gourmet shops, museum shops and florists.

Product Design Companies

This is a list of the firms represented in this book.

A-1 Product Co.
Jane Timberlake
39 Russell St.
San Francisco, CA 94109
Phone: (415) 931-4025
Fax: (415) 931-1845
E-mail: jmt@sirius.com
Web address: www.a-1product.com

Benza, inc.
Giovanni Pellone, Bridget Means
270 Park Ave. S., #6F
New York, NY 10010
Phone: (212) 677-8913
Fax: (212) 477-1181
E-mail: benzainc@aol.com

Boym Design Studio
Constantin Boym
17 Little W. 12th St., #301A
New York, NY 10014
Phone: (212) 807-8210
Fax: (212) 807-8211
E-mail: boymstudio@aol.com

Canyon Design (Rabbit Foot Inc.)
Jill Harris
23247 Oxnard St.
Woodland Hills, CA 91367-3122
Phone: (818) 704-8140
Fax: (818) 716-1204
E-mail: jillypoo@aol.com

Clark's Register
John Clark
150 Chestnut St.
Providence, RI 02903
Phone: (800) 897-0151
Fax: (401) 861-4651
Web address: www.clarksregister.com

The Clue Company
Arthur Wang
300 E. 40th St., 22D
New York, NY 10016
Phone: (212) 254-4475
Fax: (212) 254-0902

Cronan Artefact
Michael Cronan, Karin Hibma
543 8th St.
San Francisco, CA 94103-4408
Phone: (415) 241-2473
Fax: (415) 553-4553

E-mail: artefact1@aol.com
Web address: www.walkingman.com

ENCRE
René Hue
1925 Huntington Turnpike
Trumbull, CT 06611
Phone: (203) 380-2525
Fax: (203) 380-2707

Foliotrope, LLC
Daniel E. Kelm
One Cottage St., #5
Suite 5-2
Easthampton, MA 01027
Phone: (413) 529-0070
Fax: (413) 529-0071
E-mail: Foliotrope@aol.com

Higashi Glaser Design
[also see Zolo, Inc.]
Sandra Higashi, Byron Glaser
822 Caroline St.
Fredericksburg, VA 22401
Phone: (540) 372-6440
Fax: (540) 371-4573
Web address: www.zolo.com

Magnetic Poetry, Inc.
Dave Kapell
404 N. Washington Ave., Suite 101
Minneapolis, MN 55401
Phone: (800) 370-7697
Fax: (612) 338-2261
E-mail: k14dave@aol.com
Web address: www.magpo.com

[metal] Studio Inc.
Peat Jariya
1210 W. Clay St., #313
Houston, TX 77019
Phone: (713) 523-5177
Fax: (713) 523-5176
E-mail: indo@metalstudio.com
Web Address: www.metalstudio.com

Pangborn Design, Ltd.
Dominic Pangborn
275 Iron St.
Detroit, MI 48207
Phone: (313) 259-3400
Fax: (313) 259-5690
Web address: www.pangborndesign.com

Pollard Design
Jeff Pollard, Adrienne Pollard
17 Luccock Park Rd.
Livingston, MT 59047
Phone: (406) 222-2339

Fax: (406) 222-1337
E-mail: pollard@mcn.net

Sackett Design Associates
Mark Sackett
2103 Scott St.
San Francisco, CA 94115-2120
Phone: (415) 929-4800
Fax: (415) 929-4819
E-mail: sackettdsn@aol.com

Sagmeister Inc.
Stefan Sagmeister
222 W. 14th St.
New York, NY 10011
Phone: (212) 647-1789
Fax: (212) 647-1788
E-mail: sagmeis@interport.com

Studio F. kia
Marcello Albanese, Gary Knell
46 Waltham St.
Boston, MA 02118
Phone: (617) 357-5859
Fax: (617) 357-5415
E-mail: fkia@worldnet.att.net

Tilka Design
Jane Tilka
921 Marquette Ave., Suite 200
Minneapolis, MN 55402
Phone: (612) 664-8994
Fax: (612) 664-8991
E-mail: tilka@dgi.net
Web address: www.dgi.net/tilka

Vanderbyl Design
Michael Vanderbyl
171 Second St., 2nd Floor
San Francisco, CA 94105
Phone: (415) 543-8447
Fax: (415) 543-9058
E-mail: vdesign@sirius.com

Yaza
Jane Winsor, Stephanie Logan
P.O. Box 380468
Cambridge, MA 02238-0468
Phone: (617) 241-0639
Fax: (617) 241-0829

Zolo Inc. [also see Higashi Glaser Design]
524 Wolfe St., Suite 1
Fredericksburg, VA 22401
Phone: (540) 372-6440
Fax: (540) 371-4573
Web Address: www.zolo.com